55 FLOWER designs

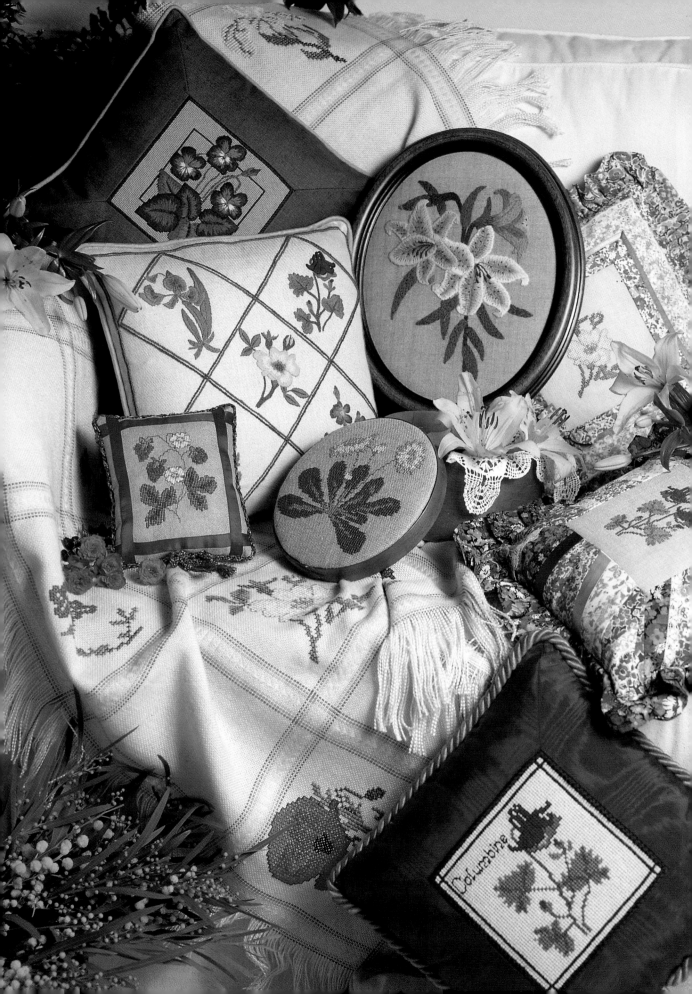

55 FLOWER designs

FOR CROSS STITCH, CANVASWORK
· AND CREWEL EMBROIDERY ·

Jane Greenoff · Sue Hawkins

David & Charles

To Bill and John, with our love . . .
and also to each other, because we are still good friends
after spending a year with this book between us.

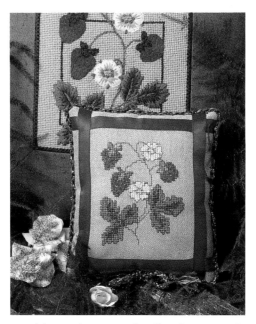

Beaded Strawberry Brooch Pillow (see page 75)

Photography by Di Lewis

A DAVID & CHARLES BOOK

Typeset by ABM Typographics Ltd
and printed in Great Britain by Butler & Tanner Ltd, Frome
for David & Charles plc
Brunel House Newton Abbot Devon

Contents

Introduction

This book has grown from our mutual experience working with and teaching counted cross stitch, counted canvaswork and crewel embroidery. It seems that, for cross stitchers, there is some sort of mystique about working charted designs on canvas. The principle is the same, but many stitchers are nervous about crossing the great divide; we hope that the designs in this book will clear up the mystery once and for all, and show you how the same chart can be interpreted either for cross stitch or for canvaswork. We hope that you will also travel a little further along the road to try the delights of crewel embroidery, again using the same designs. The book is packed with floral designs which have been translated into beautiful projects, either with a chart for cross stitch or canvaswork or with an outline to be traced for crewelwork.

We have each contributed designs stitched in our own favourite medium and then taken each other's designs and worked them again using a different technique. You will be able to see, as you look through the pages of the book, how the designs are altered and yet stay the same!

The beauty of working from charts is that the design may be worked on any evenweave material (canvas, linen or Aida) using a variety of cotton or woollen threads. We will also show you how to use these same charts for crewel embroidery by simply tracing the outlines. You will be able to produce stunning but contrasting projects such as the selection illustrated opposite. We hope that this book will change the way that you look at charts so that you can see their full potential and interpret them in your own individual way.

All projects shown in this book are stitched using either DMC stranded cotton (floss) or Appleton crewel yarn. Anchor equivalents to DMC are given throughout.

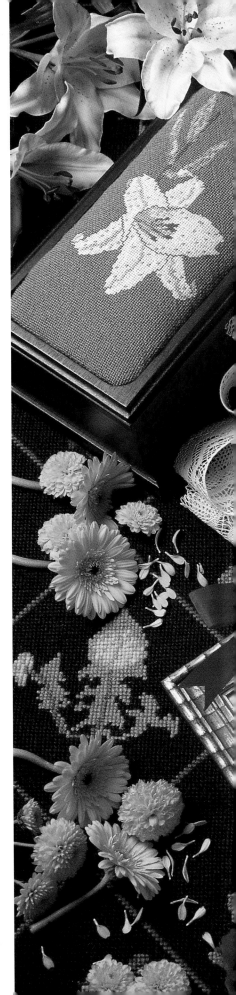

A selection of the projects featured

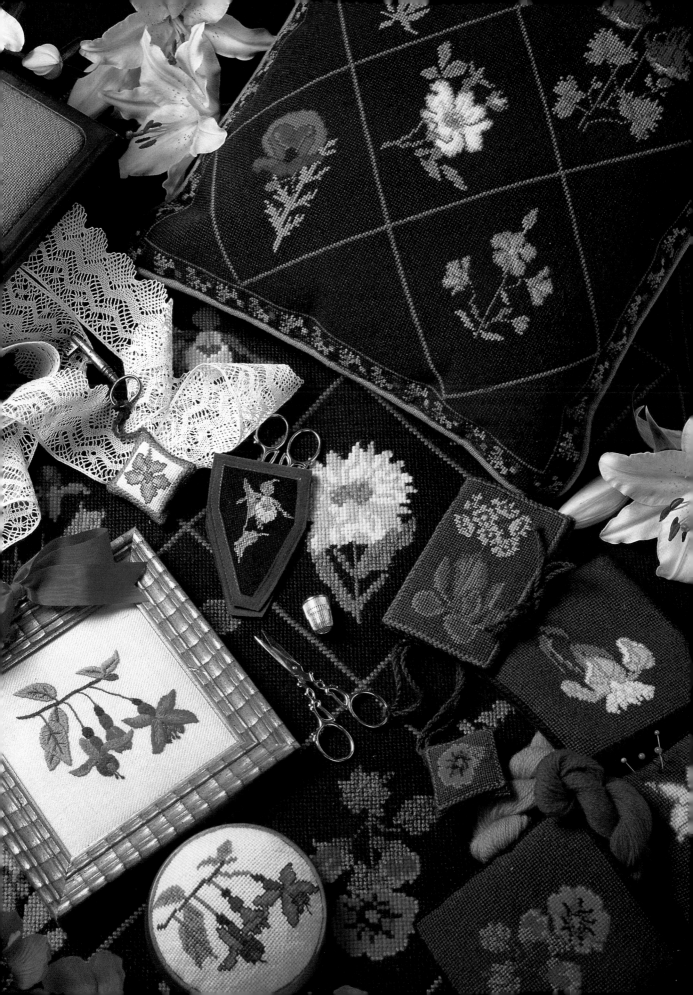

Cottage garden flowers

While teaching classes neither of us could have failed to notice that ladies who are passionate about embroidery also tend to be avid gardeners. The selection of flowers in this chapter is entirely suitable for a picture book garden. But we have included some pretty weeds to make ourselves feel more comfortable about the state that our own gardens have got into while we were working on this book!

DESIGN VERSATILITY

Eighteen floral designs are contained in this chapter, each of them being used in a wide variety of ways and interpreted in cross stitch, canvaswork and crewelwork, showing just how easily these transitions can be made. For each flower there is a chart, which can be used for cross stitch or canvaswork, and from this has been taken an outline drawing, for crewelwork.

The Poppy design shown here, for example, has been stitched in four ways, all originating from the same chart; it can also be seen on the rug on page 23, the shawl on page 41 and the cushion on page 35. For the cross stitch and canvaswork designs, use the chart (omit the charted outlines for the canvaswork pincushion). The outline drawing for the framed crewelwork picture and the black pincushion were made by tracing the cross stitch outlines,

smoothing out the stepped effect where they follow the square grid, and reducing them to the desired size (they could, of course, just as easily be increased). To help you follow the designs, the outline drawings in this section have been coloured to correspond with the charted colours.

Detailed instructions are given for the first three designs – the Poppy, Fuchsia and Auricula. If you wish to begin by stitching one of the designs given later, you should first read pages 10–21 for general instructions that are included in the text.

USING THE CHARTS

Each charted symbol represents one cross stitch or tent stitch, as appropriate. All the individual designs have been combined in the Flower Trellis rug on page 22-3. All the charts include part of the trellis which can also be seen on the Flower Trellis cushion on page 23.

You can add the flower name to the stitched piece by backstitching this in any colour of your choice (see pages 2 and 31).

(From top to bottom) Poppy Cross Stitch Greetings Card (see page 10), Poppy Crewelwork Picture (see page 12, Poppy Canvaswork Pincushion (see page 10), Poppy Woolwork Pincushion (see Chapter Three for instructions on using the woolwork technique)

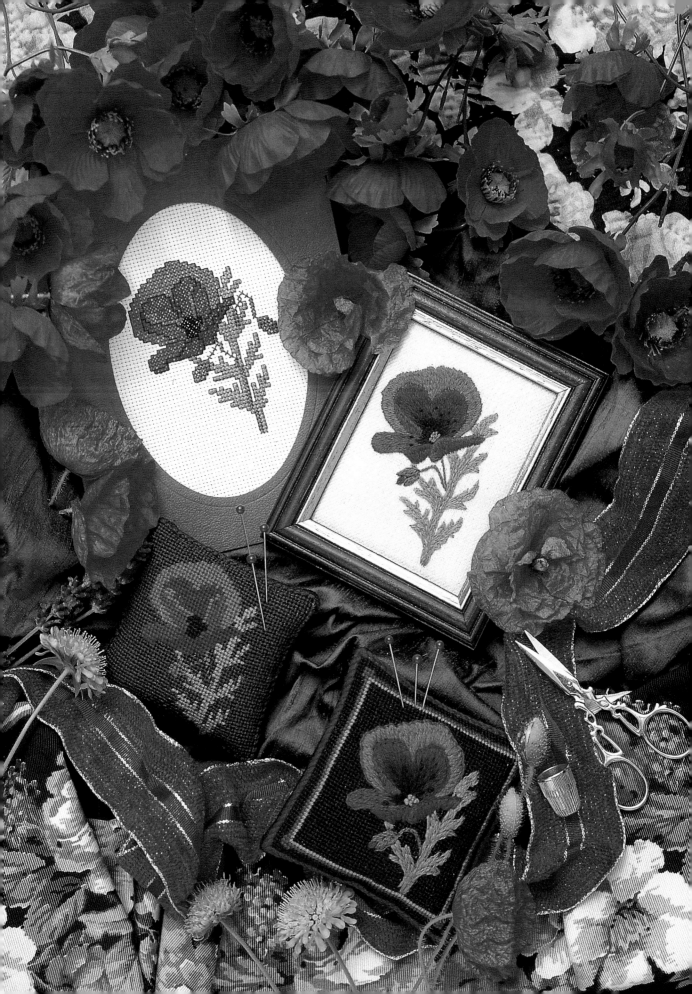

When using the designs for canvaswork, you may either include the outlines, as in the two canvaswork cushions shown on page 30, or omit them, as in the pincushion seen on the previous page. In most cases the outlines will enhance a cross stitch design, but again you may choose to omit some or all of them if you wish. Remember that separate designs can be combined, as with the rug, and you can experiment with adapting designs, for example, by moving or omitting a leaf, where this will make a combination more effective.

POPPY CROSS STITCH GREETINGS CARD

DESIGN SIZE: 2¾ x 3⅝ inches (7 x 9.5cm)
STITCH COUNT: 39 x 51

8 x 6 inches (20 x 15cm) of 14-count Aida fabric
in ecru
Stranded cottons (floss) listed on page 11
Size 24 tapestry needle
Purchased blank card with oval opening
5¾ x 3¾ inches (14.5 x 9.5cm)
All-purpose glue or double-sided adhesive tape

1 Work a narrow hem around the edge of the Aida fabric to prevent fraying. Fold the fabric in four, press lightly and mark the folds with lines of tacking (basting) stitches.
2 Following the chart on page 11 and starting at the centre, stitch the poppy, using two strands of stranded cotton (floss) for the cross stitch. Add the back stitch after the cross stitch is complete, using one strand of the shade indicated on the chart (refer to pages 111-12 for more information).
3 When the stitching is complete, check for missed stitches, then refer to page 113 for making-up instructions.

POPPY CANVASWORK PINCUSHION

DESIGN SIZE: 2¾ x 3⅝ inches (7 x 9.5cm)
STITCH COUNT: 39 x 51

8 x 8 inches (20 x 20cm) of 14-count canvas
One skein each of the Appleton crewel wools listed
on page 11 (omitting outlining colour)
Two skeins of Appleton crewel wool 926 for the
background
Size 22 tapestry needle
6 x 6 inches (15 x 15cm) of backing fabric

Three strands of crewel wool are used throughout
Stitches used: tent stitch, diagonal tent stitch and
long-legged cross stitch (see pages 116–17)

1 Bind the edges of the canvas with masking tape. Fold the fabric in four to find the centre and mark the folds with pencil lines. Following the chart on page 11 and starting at the centre, stitch the poppy in tent stitch.
2 Draw a 4 inch (10cm) square on the canvas, centring the completed poppy; fill this area with diagonal tent stitch in the background colour.
3 Work a row of long-legged cross stitch to surround the background area.
4 Refer to page 117 for stretching instructions and for details on making-up the pincushion see page 122.

POPPY

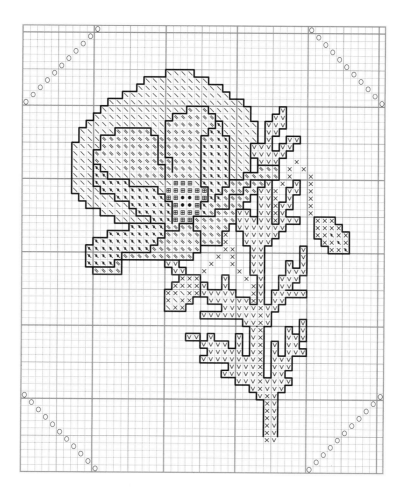

POPPY

		DMC	ANCHOR	APPLETON
•	black	310	0403	998
⊞	dark blue	939	0152	106
◩	dark red	304	047	504
◪	orangey red	349	013	866
◺	orange	350	011	864
ⱱ	medium green	562	0210	831
⊠	dark green	561	0212	832

Optional outline

	DMC	ANCHOR	APPLETON
Flowers	939	0152	106
Leaves	561	0212	832

POPPY CREWELWORK PICTURE

8 x 8 inches (20 x 20cm) of linen twill
One skein each of the Appleton crewel wools listed
on page 11
Size 7 crewel needle
6 inch (15cm) embroidery hoop or small frame
Water-soluble pen
Black felt-tip pen
Sheet of tracing paper
Purchased frame at least 3 ½ x 4 ½ inches
(9 x 11.5cm)

**One strand of crewel wool is used throughout
Stitches used: split back stitch, long-and-short stitch,
French knots and stem stitch (see pages 119–21)**

1 Unless you are using a transfer (see page 127), you will need to trace the outline on to your fabric. Trace the black outlines of the drawing (right) on to the tracing paper, using the black felt-tip pen. To transfer the design lines to fabric, we used an artist's light box, but you can use daylight as your light source by taping your tracing to a window pane and then taping the square of linen twill over it. The outline will show through the fabric and you will be able to trace it, using the water-soluble pen.

2 Mount the linen into your hoop or frame. It is important to keep the fabric taut as some of the stitches used in crewelwork are quite long and it is easy to bunch up the fabric if it is not held tight while you are working.

3 The drawing (right) has been coloured to help you with placing the colours but you can also refer to the chart on page 11 which will show you which colours are in each part of the flower. By doing this, you will find how easy it is to translate a cross stitch chart into a crewelwork design. Also look at the two stage photographs opposite. Begin with orange and work a split back stitch outline to the large petal at the back of the poppy. This outline will give a slightly raised effect to the petal and also enables you to

give a much better edge to the long-and-short stitch which you will then work over the split back stitch.

4 Still using orange, fill the large petal with long-and-short stitch. When working long-and-short stitch, always split the threads of each successive layer of stitching to ensure a good blending of colour and smooth stitches. Your stitches will seem longer than necessary because they will be shortened by the following layer of stitches.

The most important thing to remember with this form of embroidery is that great care needs to be taken with the direction of each stitch. For a realistic effect, your stitches should seem to radiate out of the centre of the flower, and you will have to overlap (or underlap) some stitches towards the centre to achieve this.

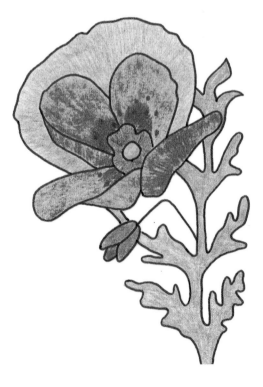

12

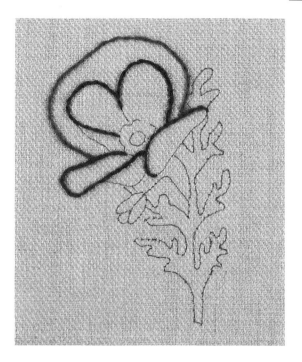

The outline does not show on the finished work but gives a padded effect to the petal

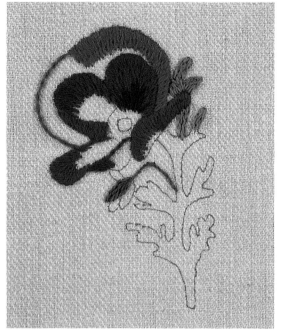

All these petals have been partly stitched to show how splitting the threads already worked blends the colours

13

5 Work the two lower petals in orangey red and dark red. The one on the right has a split back stitch underline and first row of long-and-short stitch in orangey red, and is completed in dark red. The one on the left has a split back stitch underline and top surface in orangey red, and an under surface in dark red long-and-short stitch.

6 Work the two inner petals in dark red and very dark red. (Very dark red, which is the outline colour on the chart, has been used here to give depth of colour to the centre of the flower.) The upturned edge of the left-hand petal is orangey red; when you work the underlining split back stitch this should also be in orangey red for this short length. The centre of the flower

is completed with a circle of dark blue. We then added randomly placed French knots in dark blue, set close to the centre of the poppy, and a cluster of gold French knots in the middle.

7 Work the leaf in long-and-short stitch in medium green, beginning at the top leaf tips and working down to join in with the stem. Repeat for each leaf until you reach the end of the stem, then work the bud in dark green and dark red. The flower and the bud stems are in dark green stem stitch.

8 When the stitching is complete, rinse the finished piece gently to remove the water-soluble pen outlines and refer to page 121 for stretching and mounting instructions.

FUCHSIA CROSS STITCH GREETINGS CARD

DESIGN SIZE: 3 1/2 x 3 inches (9 x 7.5cm)
STITCH COUNT: 50 x 44

8 x 6 inches (20 x 15cm) of 14-count Aida fabric
in ecru
Stranded cottons (floss) listed
on page 16
Size 24 tapestry needle
Purchased blank card with oval opening
5 3/4 x 3 3/4 inches (14.5 x 9.5cm)
All-purpose glue or double-sided adhesive tape

1 Stitch a narrow hem around the edge of the Aida fabric to prevent fraying. Fold it in four, press lightly and mark the folds with a line of tacking (basting) stitches.

2 Following the chart on page 16 and starting at the centre, stitch the fuchsia, using two strands of stranded cotton (floss) for the cross stitch. Add the back stitch after the cross stitching is complete, using one strand of the shade indicated on the chart (refer to pages 111–12 for further information).

3 Add the optional stamen in one strand of stranded cotton using a single long stitch for each. You could add a French knot or bead to the tip.

4 When the stitching is complete, check for missed stitches and refer to page 114 for making-up instructions.

FUCHSIA CANVASWORK PINCUSHION

DESIGN SIZE: 3 1/2 x 3 inches (9 x 7.5cm)
STITCH COUNT: 50 x 44

8 x 8 inches (20 x 20cm) of 14-count canvas
One skein each of the Appleton crewel wools listed
on page 16 (omitting outlining colour)
Two skeins of Appleton crewel wool 882 for the
background
Size 22 tapestry needle
Purchased wooden pincushion base 4 1/2 inches
(11.5cm) in diameter
Masking tape

**Three strands of crewel wool are used throughout
Stitches used: tent stitch, diagonal tent stitch
(see page 116)**

1 Bind the edges of the canvas with masking tape. Fold the fabric in four to find the centre and mark the folds with a pencil line. Following the chart on page 16 and starting at the centre, stitch the fuchsia in tent stitch, ignoring the charted outlines.

2 Draw a 4 1/2 inch (11.5cm) circle on the canvas, centring the completed fuchsia; fill this area with diagonal tent stitch in the background colour.

3 Refer to page 117 for instructions on how to stretch your finished embroidery, and then carefully follow the manufacturer's instructions for mounting the embroidery on the wooden base.

(From top to bottom) Fuchsia Crewelwork Picture (see page 17), Fuchsia Cross Stitch Greetings Card, Fuchsia Canvaswork Pincushion

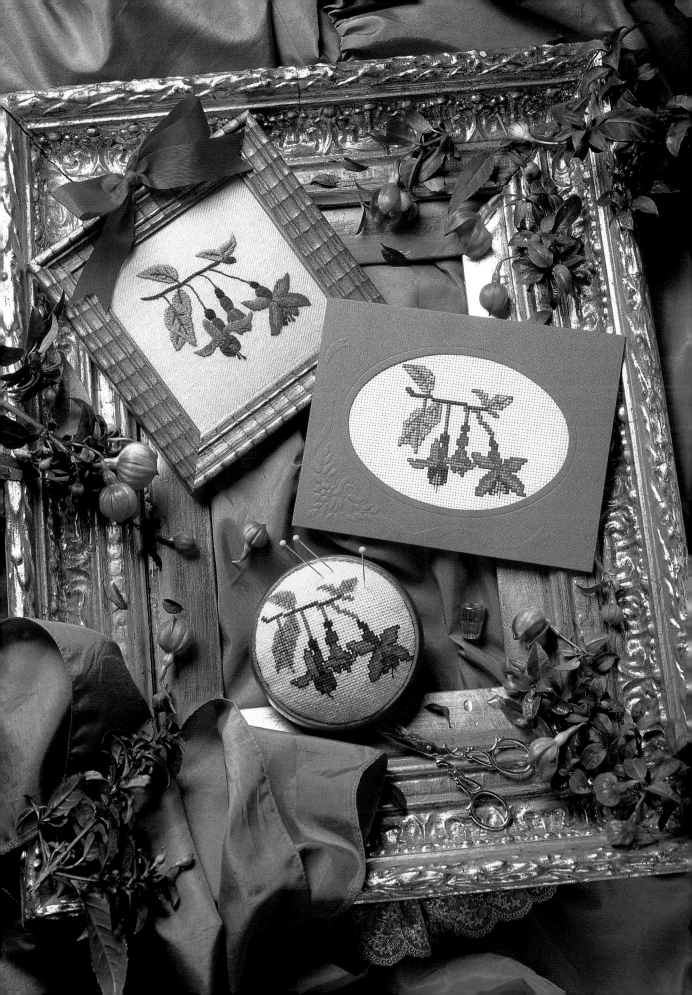

FUCHSIA

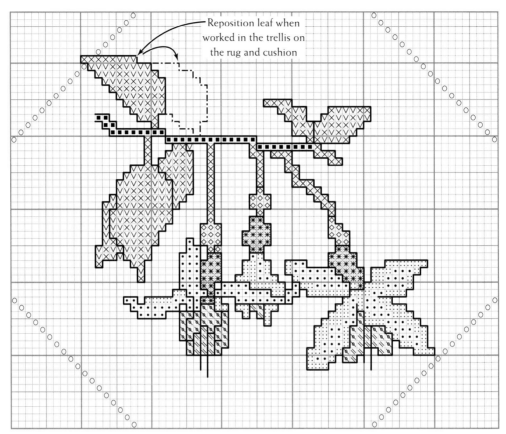

Reposition leaf when worked in the trellis on the rug and cushion

FUCHSIA

		DMC	ANCHOR	APPLETON
◇	dark red	814	045	716
✳	dark pink	600	078	805
⊡	light pink	602	063	801
◩	dark purple	550	0101	456
▨	lilac	553	098	454
⊞	medium pink	601	077	803
⊠	medium green	367	0216	403
■	brown	898	0359	956
▽	dark green	368	0214	402

Optional outline

Writing and flowers	814	045	716
Stamen	550	0101	456
Leaves	367	0216	403
Twig	898	0359	956

FUCHSIA CREWELWORK PICTURE

8 x 8 inches (20 x 20cm) of linen twill
One skein each of the Appleton crewel wools listed
opposite
Size 7 crewel needle
6 inch (15cm) embroidery hoop or small frame
Water-soluble pen
Black felt-tip pen
Sheet of tracing paper
Purchased frame at least 4 x 4 inches (10 x 10cm)

One strand of crewel wool is used throughout
Stitches used: split back stitch, long-and-short stitch,
French knots and stem stitch (see pages 119–21)

1 As the Poppy was the first flower in this chapter, the crewelwork instructions were given in some detail. To avoid repeating some of the more general instructions, we suggest that you read through pages 12 and 13, if you have not worked the Poppy, before starting the Fuchsia. The two partly-worked examples pictured below will also help you to create the desired effect with your stitches.

2 Trace the outline on to your fabric as for the Poppy (see page 12), and mount it in your hoop or frame.

3 For the leaves, work a split back stitch underline, then fill in with medium green long-and-short stitch making the veins and stems in dark green stem stitch.

4 For the flowers, use long-and-short stitch, embroidering the lower petals in lilac and dark purple, and the middle petals in medium and light pink. For the tops of the flowers, use dark pink for the lower part and dark red for the upper part.

5 Work the stems of the flowers in dark green, using stem stitch. Work the bud at the end of the twig in dark green long-and-short stitch and make the twig with two adjacent rows of brown stem stitch. Form the stamens with a single stitch and a French knot in dark purple.

6 When the stitching is complete, rinse the finished piece gently to remove the water-soluble pen outlines and refer to page 121 for stretching and mounting instructions.

17

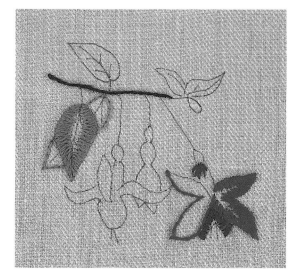

A long stitch should alternate with a short one and each stitch should seem to radiate out of the centre of each flower or leaf

The stitches of the second layer of long-and-short stitch should lie in the same direction as the first

AURICULA CROSS STITCH PICTURE

DESIGN SIZE: 2½ x 4½ inches (6 x 11cm)
STITCH COUNT: 36 x 61

6 x 8 inches (15 x 20 cm) of 14-count Aida fabric
in shade 304
Stranded cottons (floss) listed on page 20
Size 24 tapestry needle
Purchased picture frame at least 3 x 5 inches
(7.5 x 13cm)

1 Work a narrow hem around the edge of the Aida fabric to prevent fraying. Fold the fabric in four, press lightly and mark the folds with lines of tacking (basting) stitches.

2 Following the chart on page 20 and starting at the centre, stitch the auricula, using two strands of stranded cotton (floss) for the cross stitch. Add the back stitch after the cross stitch is complete, using one strand of the shade indicated on the chart (refer to pages 111–12 for more information).

3 When the stitching is complete, check for missed stitches, then refer to page 114 for making-up instructions.

AURICULA CANVASWORK NEEDLEBOOK

DESIGN SIZE: 2½ x 4½ inches (6 x 11cm)
STITCH COUNT: 36 x 61

8 x 10 inches (20 x 25cm) of 14-count canvas
One skein each of the Appleton crewel wools listed
on page 20
Four skeins of Appleton crewel wool 926 for the
background
Size 22 tapestry needle
Masking tape
8 x 10 inches (20 x 25cm) of blue felt for lining
Two 5 x 3½ inches (13 x 9cm) pieces of white or
cream felt to make the pages of the needlebook

Three strands of crewel wool are used throughout, except for the flower outline, stitched with two strands
Stitches used: tent stitch, diagonal tent stitch and long-legged cross stitch (see pages 116–17)

1 Bind the edges of the canvas with masking tape. Fold your fabric in half across the length to find the central canvas thread; count two threads on each side of this, and make a pencil line in the groove next to each (these lines should be five threads apart and will form the spine of the needlebook). Draw an oblong 40 threads across by 65 threads down against each line to form the front and back covers. When counting for canvaswork, always count threads and not holes.

2 Using tent stitch, work the flower design centrally in the right-hand oblong, using the chart on page 20. You will have two stitches between the flower and the border on all sides.

3 Fill in the blue background, using diagonal tent stitch, and completely fill the other large oblong, which is the back cover.

4 Work a single row of blue tent stitch on the middle thread of the five threads left for the spine. Work a row of long-legged cross stitch around each oblong (back and front covers), which will fill the two rows of two threads left for the spine. We used dark green for this long-legged edge but you could equally well use the blue background colour.

5 Refer to page 117 for stretching and page 122 for making-up instructions.

(From top to bottom) Auricula Crewelwork Picture (see page 21); Auricula Cross Stitch Picture; Auricula Canvaswork Pincushion

AURICULA

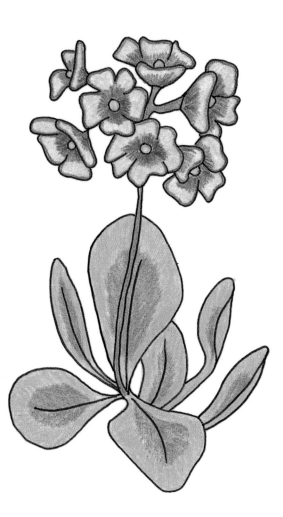

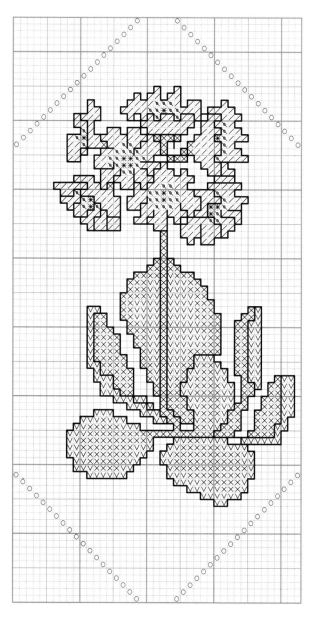

AURICULA

	DMC	ANCHOR	APPLETON
purple	327	0100	606
yellow	744	0301	471
flesh	948	0778	753
medium green	502	0877	643
dark green	501	0878	645

Optional outline

	DMC	ANCHOR	APPLETON
Flowers	327	0100	606
Leaves	501	0878	645

AURICULA CREWELWORK PICTURE

8 x 8 inches (20 x 20cm) of linen twill
One skein each of the Appleton crewel wools listed
on page 20
Size 7 crewel needle
6 inch (15cm) embroidery hoop or small frame
Water-soluble pen
Black felt-tip pen
Sheet of tracing paper
Purchased frame at least 5 x 3 inches (13 x 7.5cm)

One strand of crewel wool is used throughout
Stitches used: split back stitch, long-and-short stitch,
French knots and stem stitch (see pages 119–21)

1 As the Poppy was the first flower in this chapter, the crewelwork instructions were given in some detail. To avoid repeating some of the more general instructions, we suggest that you read through pages 12 and 13 if you have not worked the Poppy before starting the Auricula.

The two partly-worked examples below will also help you.

2 Trace the outline on to your fabric as for the Poppy (see page 12), and mount it in your hoop or frame.

3 Work the leaves with a split back stitch underline, then fill with long-and-short stitch, using medium green around the edges and dark green at the centre.

4 Work the petals in flesh, using long-and-short stitch and shading with purple to the centre. The centre of each flower is a cluster of yellow French knots, and each petal is edged with purple split back stitch.

5 Embroider the flower stems in dark green stem stitch.

6 When the stitching is complete, rinse the finished piece gently to remove the water-soluble pen outlines, then refer to page 121 for stretching and mounting instructions.

21

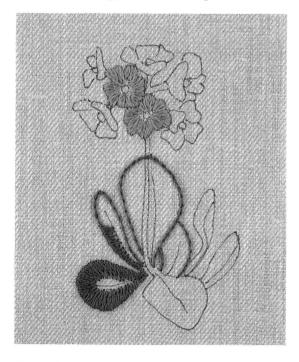

The petals are not outlined in split back stitch as a purple outline is added later

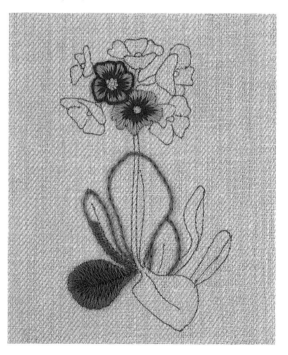

Do not leave a gap for the flower stalk, work it on top of the completed leaf

FLOWER TRELLIS RUG AND CUSHION

The beautiful rug opposite would sit well in front of any hearth. We wanted to include a large project in this book as well as all the small ones that are so suitable for gifts, but when the rug had been designed we realized that we had created all the small designs as well! Once you have stitched the rug, you can select from the other soft furnishing ideas in this chapter. Your decor will come alive as the flowers on the rug are echoed around the room in different ways.

The cushion shown uses just five of the flowers; you could choose others or work a set of cushions using different selections. Part of the trellis design has been included on every flower chart to make it easy for you to position the flower of your choice.

Although the rug is a large project, the overall design is broken into smaller areas by the trellis. As you work, you will fill one diamond of the trellis at a time, and in this way the work is made less daunting.

The rug is embroidered in cross stitch on canvas, which makes it hardwearing and ensures that it will retain its shape. The cushion is worked in tent stitch, and the flowers have been enhanced by using some of the outlines included on each chart.

We chose charcoal black as our background colour; this is very dramatic, but if you want a softer look you might use cream or a pastel colour. To give you ideas for your colour choice, look at the other pictures in this chapter, which show the flowers on various backgrounds.

Flower Trellis Rug (see page 24) and Flower Trellis Cushion (see page 27)

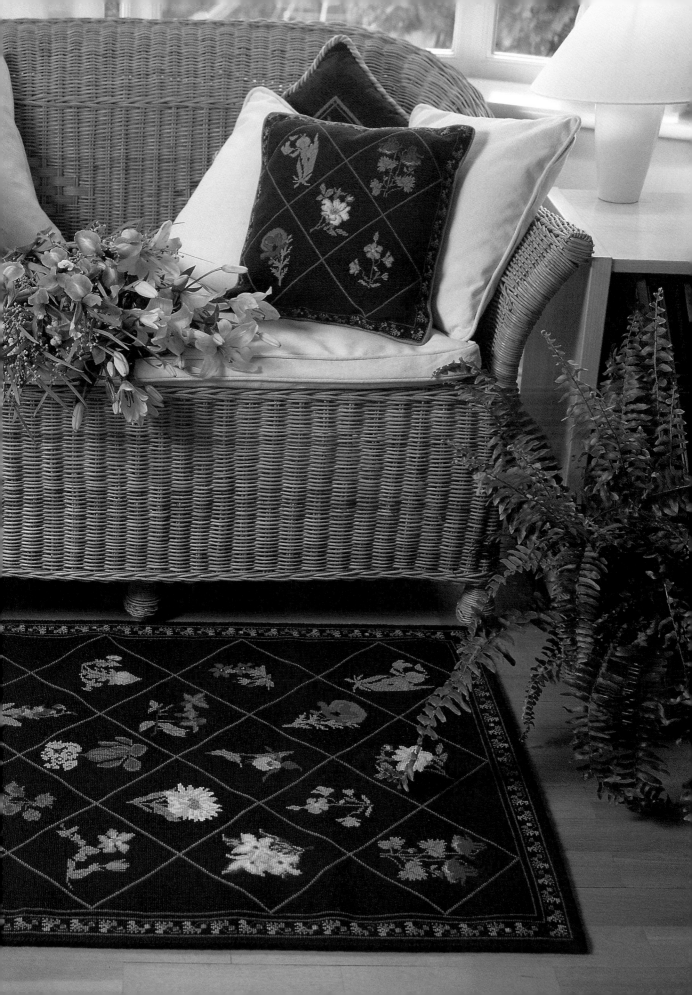

FLOWER TRELLIS RUG

FINISHED SIZE: 31 x 38 inches (77.5 x 95cm)
STITCH COUNT: 403 x 313

39 x 48 inches (100 x 120cm) of 10-count canvas
One skein each of the Appleton crewel wool 106,
202, 205, 226, 451, 452, 454, 456, 464, 471, 473,
504, 603, 606, 693, 695, 696, 711, 714, 716, 742,
744, 753, 766, 801, 803, 805, 823, 852, 862, 864,
866, 872, 881, 882, 891, 892, 894, 896, 941, 943,
945, 946, 948 and 956
One hank each of Appleton crewel wool 354, 402,
403, 405, 543, 544, 643, 645, 831 and 832
Two hanks each of Appleton crewel wool 903 and
904 for the trellis
24 hanks of Appleton crewel wool 998 for the
background
Size 24 tapestry needle
Heavy felt or linen for backing

Three strands of crewel wool are used throughout,
except for the long-legged cross stitch edge which
uses six strands
Stitches used: cross stitch and long-legged cross
stitch (see pages 116 and 117)

1 Work without a frame, loosely rolling the canvas in your hand to gather up the excess as you stitch. Begin stitching in one corner: measure in 4 inches (10cm) each way, and begin cross-stitching the dark gold lines that mark the outer border. Including the corner stitches, make 305 stitches along each short side, and 395 stitches along each long side.

2 Following the chart and counting in from the outer border line, stitch the two inner border lines, also in dark gold.

3 Work the trellis diamond. Once this shape has been completed, the remaining diamonds will fall into place. You now have the option of either filling in the first diamond or stitching the entire trellis before filling in any of the shapes.

4 Use the placement diagram to position the flowers (the arrows show the direction of each flower) and refer to the individual charts to stitch each flower. The trellis symbols on the charts will help you to centre the flowers correctly. You may fill in the background around each flower now or later (see step 6).

5 Once the trellis and all the flowers are complete, work the leaf border between the two dark gold lines already stitched. The flower buds featured in this border were taken from the darker flower colours and randomly placed.

6 Complete all the background, then stitch four rows of background colour beyond the dark gold outer border line.

7 To finish, work a row of long-legged cross stitch all around the edge of your rug; this will help the canvas to fold under neatly, and gives a braided effect to the edge.

8 Refer to page 117 for stretching and back with felt or linen as preferred.

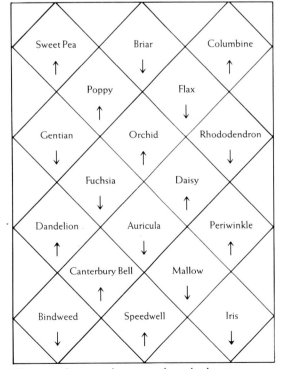

*Placement diagram: the arrows show the direction
for each flower but you may prefer to place them all
in the same direction*

Cottage Garden Flowers

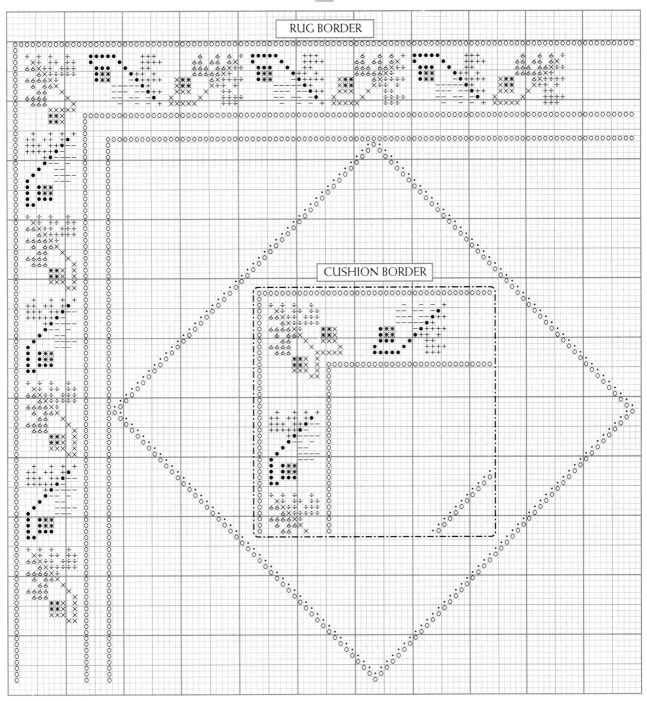

RUG BORDER

CUSHION BORDER

FLOWER TRELLIS RUG AND CUSHION

APPLETON

⊙	golden brown	904
⊡	golden brown	903
⊞	sea green	403
⊠	sea green	405
⌀	grey green	354
●	peacock blue	645
⊞	peacock blue	643
⊟	bright peacock blue	831
✳	dark flower shades	

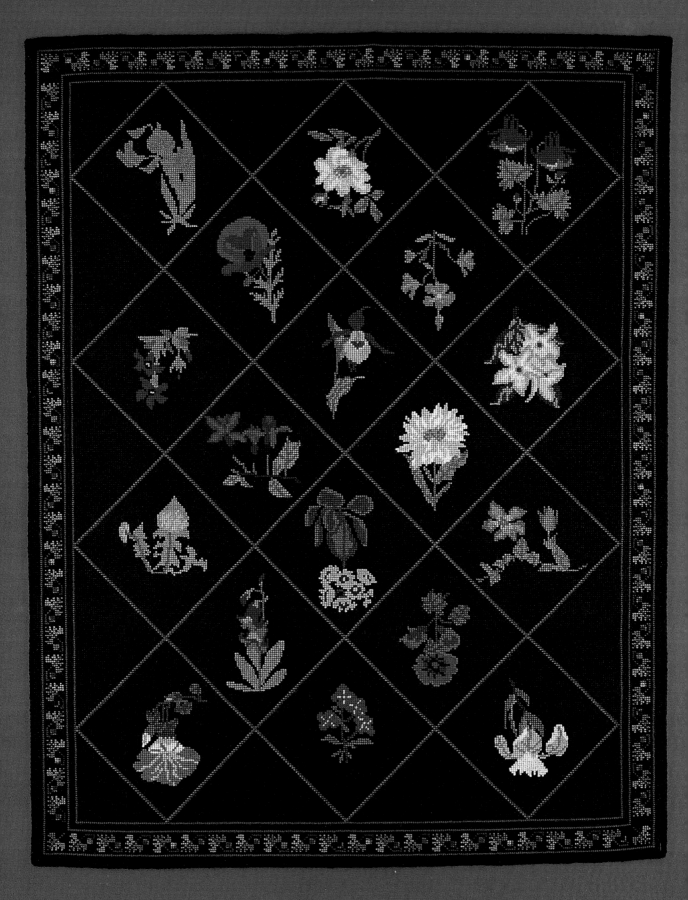

FLOWER TRELLIS CUSHION

FINISHED SIZE: 14½ x 14½ inches (37 x 37cm)
STITCH COUNT: 206 x 206

20 x 20 inches (50 x 50cm) of 14-count canvas
One skein each of the Appleton crewel wools in the
following colours: 106, 354, 451, 452, 471, 504,
543, 695, 696, 742, 744, 832, 841, 864 and 866
Three skeins each of 402, 403, 405, 643, 645, 831,
903 and 904
Four hanks of 998 for the background
Size 22 tapestry needle
20 inches (50cm) of backing fabric

Three strands of crewel wool are used throughout
Stitches used: tent stitch and diagonal tent stitch
(see page 116)

1 As with the flower trellis rug, begin at one
corner: measure in 2½ inches (6cm) from each
edge and this will be a corner of your cushion.
2 Working from the chart on page 25, and
using tent stitch, begin the dark gold lines that
mark the inner and outer edges of the leaf border
and work both of them to the point where the
first trellis diamond joins them. Work this first
diamond in dark gold and add the second row of
light gold. Once this first section of border and
the first trellis square are worked, the rest of the
cushion will fall into place. You may choose to
stitch the entire trellis first or fill each square as
you go.
3 Use the placement diagram to position the
flowers and refer to the first five charts in this
chapter for stitching each flower. The trellis
symbols on each individual chart will enable you

to centre the flowers correctly. On the cushion
pictured on page 23 the optional outlines have
been stitched on the flowers only.
4 Once the trellis and all the flowers are com-
plete, work the leaf border between the two dark
gold lines that you will already have stitched.
The flower buds in this border were stitched
from the darker colours of all the flowers and
randomly placed.
5 Fill in the background, using diagonal tent
stitch.
6 Refer to page 117 for stretching instructions
and to page 123 for making-up.

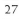

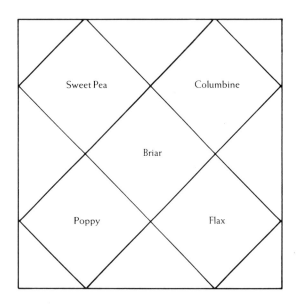

Placement diagram for the flowers on our cushion. You
may prefer to work another selection

(Opposite) Flower Trellis Rug. If you choose to use the
rug as a wall hanging you may prefer all the flowers to
be upright

SWEETPEA

The Sweetpea can be seen in the Flower Trellis rug and cushion on page 23, the crewelwork cushion on page 35, and the cross stitch bell pull on page 51. To calculate the finished design size for any of the projects refer to the instructions on page 110.

SWEETPEA

		DMC	ANCHOR	APPLETON
⊠	pale lilac	554	097	451
⊺	purple	553	098	452
⊠	light green	368	0214	402
2	medium green	320	0215	354
	Optional outline			
	Flowers	315	0896	714
	Leaves	368	0214	402

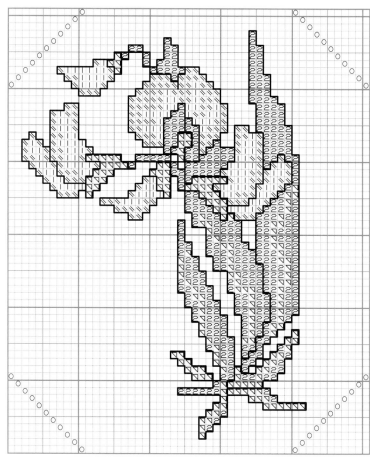

28

STITCH COUNT:
40 x 56

COLUMBINE

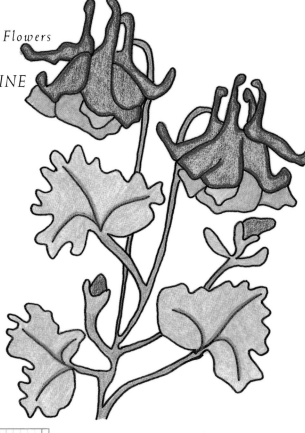

This pretty garden Columbine can be seen in the Flower Trellis rug and cushion on page 23, the crewelwork cushion on page 35, and the Afghan shawl on page 41. To calculate the design size for a project refer to page 110.

COLUMBINE

		DMC	ANCHOR	APPLETON
◹	light green	320	0215	354
⊟	dark red	3685	069	948
⊡	pink	3687	068	945
✳	yellow	744	0301	471
⊠	medium green	367	0216	403

Optional outline

Flowers	3685	069	948
Leaves	367	0216	403

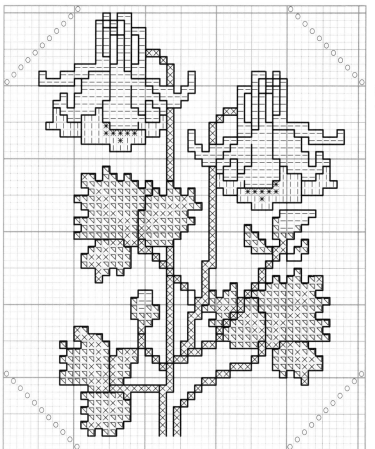

STITCH COUNT:
43 x 58

COLUMBINE AND BRIAR ROSE CUSHIONS

The four cushions seen below show how the same chart can be used in a variety of ways. One panel of each pair has been stitched using the Columbine chart on page 29 and the other using the Briar Rose chart on page 32. All four panels are in cross stitch – two on canvas in wool and two on linen in stranded cotton (floss).

The two frilled cushions have cross stitch panels on pastel-coloured 28-count linen, the cross stitch being worked in two strands of stranded cotton (floss) and the back stitch in one strand. To add an attractive framework to the Columbine cushion, we made a square of random patchwork from Liberty lawn, ribbons and lace; this square was then cut up to make the side panels that frame the embroidery and a frill was

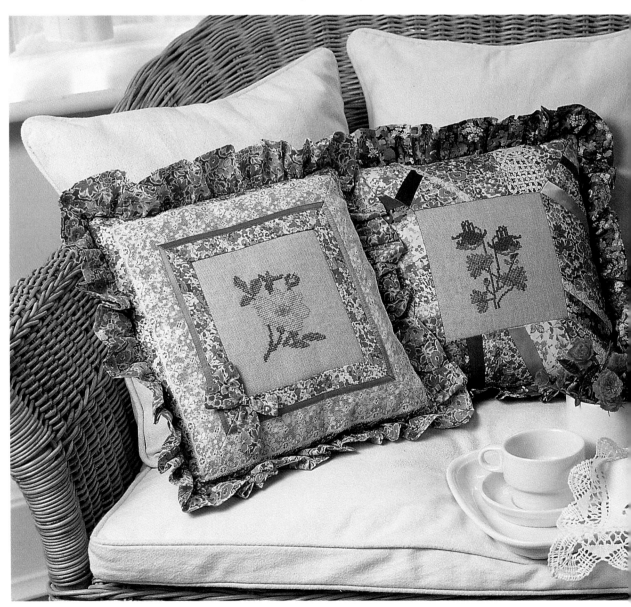

added. For the Briar Rose cushion, we covered the lawn fabric of the outer border with wide cotton lace, edging the division between the inner and outer borders with ribbon.

The two corded cushions are worked in cross stitch on 10-count canvas, using three strands of Appleton crewel wool. A row of long-legged cross stitch borders each panel. The panels have been inset into moiré satin and a carefully-chosen cord added to the outer edge. You will find instructions for making cushion covers with inset designs on page 123. We are not giving

specific instructions for these four cushions; they have been included to show how important it is to search for fabrics, braids, ribbons and lace to enhance your embroidery and to give an idea of the differing effects that can be achieved. We hope they will encourage you to use the charts in this book while experimenting with your own ideas for various projects.

These four cushions illustrate the very varied effects that can be achieved from the same charts by using different techniques, threads and fabrics

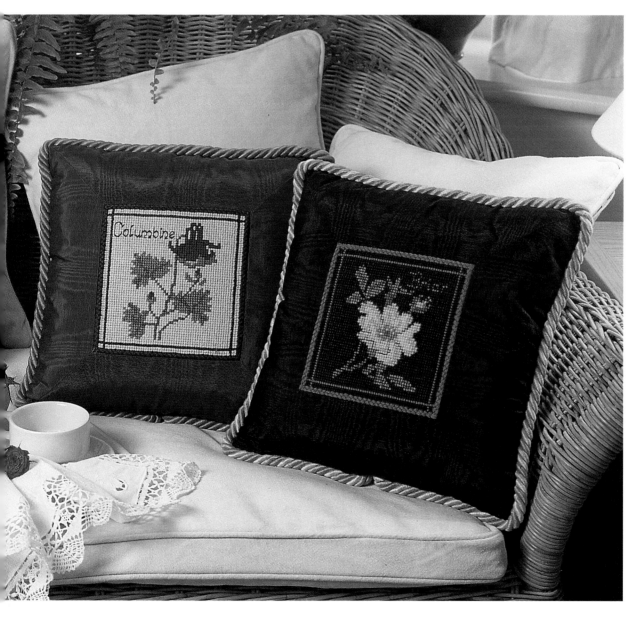

BRIAR ROSE

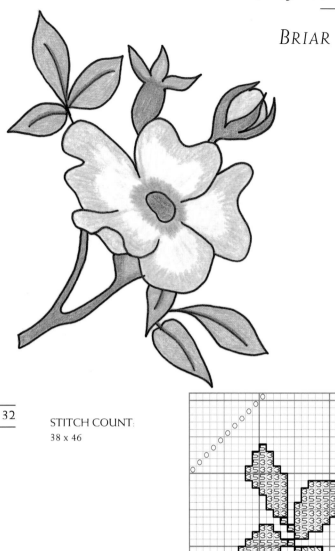

The wild Briar Rose is featured on the Flower Trellis rug and cushion on page 23, the cushions on pages 30–1, the crewelwork cushion on page 35, and the shawl on page 41. To calculate the design size for a project refer to the instructions on page 110.

BRIAR ROSE

		DMC	ANCHOR	APPLETON
⊟	old gold	729	0890	695
2	dark gold	680	0901	696
⊠	yellow	744	0301	471
⊠	cream	712	0926	841
3	green	320	0215	354
5	medium green	367	0216	403

Optional outline

Flowers		680	0901	696
Leaves		367	0216	403

STITCH COUNT:
38 x 46

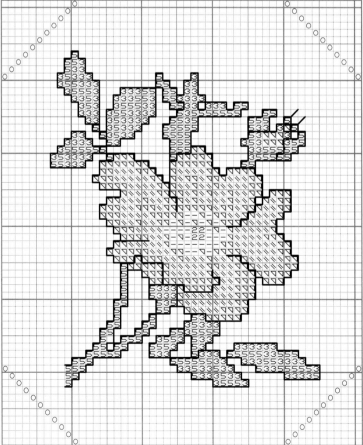

FLAX

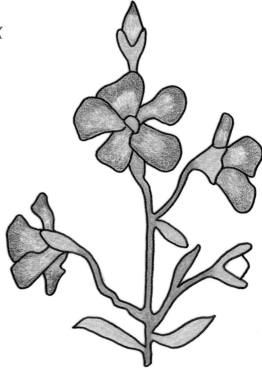

The Flax can be seen in the Flower Trellis rug and cushion on page 23, the crewelwork cushion on page 35, the shawl on page 41, and the bell pull on page 51. To calculate the design size for a project refer to the instructions on page 110.

FLAX

		DMC	ANCHOR	APPLETON
⊟	sky blue	809	0130	744
⊡	light blue	800	0144	742
◹	yellow	744	0301	471
⊡	leaf green	3347	0266	543
⊠	dark green	367	0216	403
Optional outline				
	Flowers	3347	0266	543
	Leaves	367	0216	403

STITCH COUNT:
37 x 49

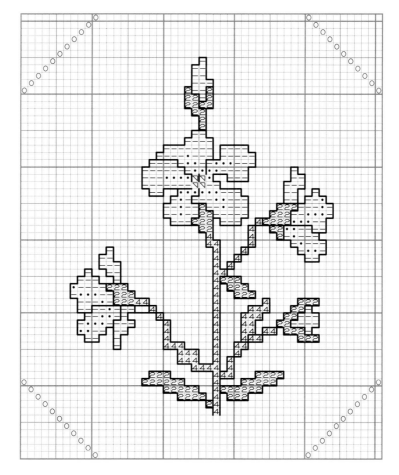

CREWELWORK FLOWER TRELLIS CUSHION

Compare this cushion with the canvaswork version pictured on page 23 and you will see how the same design, when translated into crewelwork, can look very different and yet still complement its partner perfectly. For the cushion shown opposite we used the outlines given for the Poppy on page 12, the Sweetpea on page 28, the Columbine on page 29, the Briar Rose on page 32 and the Flax on page 33. You may prefer to make your own choice or even to make a pair of cushions with different sets of flowers.

20 x 20 inches (50 x 50cm) of linen twill fabric
One skein each of the Appleton crewel wools listed on each chart
Two skeins each of Appleton crewel wools 902 and 903 for the trellis
Size 7 crewel needle
Large embroidery hoop or frame
Water-soluble pen
Black felt-tip pen
Sheet of tracing paper
Ruler

**One strand of crewel wool is used for all the flower motifs and two strands for the trellis lines
Stitches used: split back stitch, long-and-short stitch, French knots and stem stitch (see pages 119–21)**

1 Draw a 12½ inch (32cm) square on your fabric, using the ruler and water-soluble pen. Mark the measurements along each edge and draw the trellis pattern, using the diagram provided on this page.
2 Trace your chosen flower outlines on the tracing paper, using the felt-tip pen. Trace one flower in each diamond of the trellis, following the tracing instructions given for the Poppy on page 12.
3 First work the trellis in stem stitch, using two strands of 903 and covering all the lines on your fabric. Next, work a second row of stem stitch in two strands of 902, just next to and inside the

first row of stitching on the inner lines of the trellis only (not the outer square).
4 Complete each flower, using the charts and coloured line drawings to help with the placement of the colours. More detailed instructions are given for the first three flowers in this chapter, the Poppy, the Fuchsia and the Auricula. If you want to work the later flowers before you have worked any of these three, you should read pages 10–21 for the general instructions that are included in the text, taking special note of the partly-worked examples to help you with the stitching. Also use the colour picture opposite, and refer to pages 119–21 for instructions on the stitches used.
5 When the stitching is complete, rinse the finished piece gently to remove the water-soluble pen outlines and refer to page 121 for stretching and to page 123 for making-up instructions.

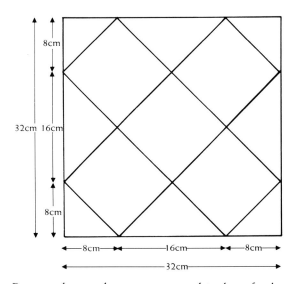

Diagram showing the measurements and markings for the trellis

(Opposite) Crewelwork Flower Trellis Cushion

34

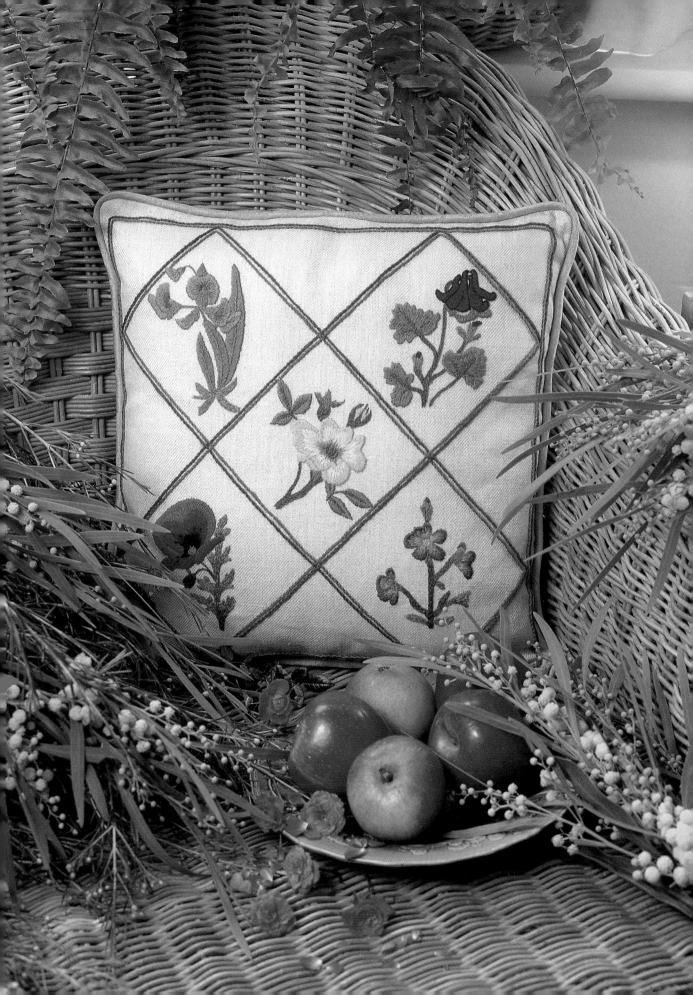

BINDWEED

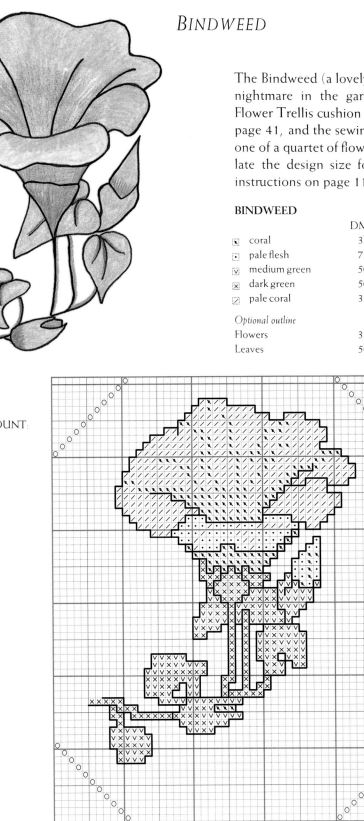

The Bindweed (a lovely flower in the wild and a nightmare in the garden!) is featured in the Flower Trellis cushion on page 23, the shawl on page 41, and the sewing tidy on page 45, and is one of a quartet of flowers on page 51. To calculate the design size for a project refer to the instructions on page 110.

BINDWEED

		DMC	ANCHOR	APPLETON
⊠	coral	352	09	202
⊡	pale flesh	754	4146	881
⊻	medium green	502	0877	643
⊠	dark green	501	0878	645
⊿	pale coral	353	06	205

Optional outline
Flowers	350	011	864
Leaves	501	0878	645

STITCH COUNT:
38 x 50

36

DAISY

The charming Daisy can be seen on the Flower Trellis rug on page 23, the shawl on page 41, and the pendant brooch on page 53. To calculate the design size for a project refer to the instructions on page 110.

DAISY

		DMC	ANCHOR	APPLETON
✳	pale orange	722	0323	862
⊡	coffee	434	0365	766
◩	yellow	744	0301	471
◺	pale lemon	677	0300	872
▽	green	320	0215	354
☒	dark green	367	0216	403

Optional outline

Flowers	434	365	766
Leaves	367	0216	403

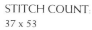

STITCH COUNT:
37 x 53

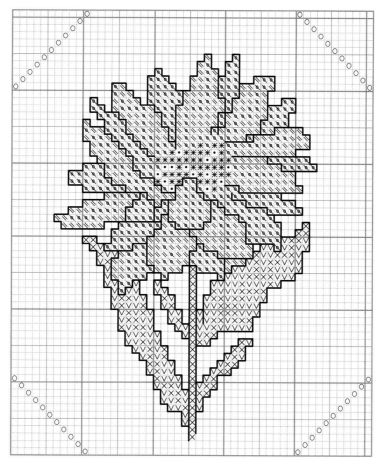

GENTIAN

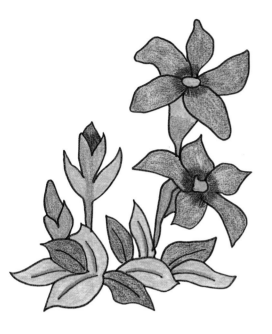

The Gentian, found wild in the Alps, can be seen on the Flower Trellis rug on page 23, the shawl on page 41, and the pewter pot top on page 53. To calculate the design size for a project refer to the instructions on page 110.

GENTIAN

		DMC	ANCHOR	APPLETON
◳	bright blue	797	0132	823
⊟	very dark blue	939	0152	852
⊡	yellow	676	0891	693
2	sage green	320	0215	354
3	light sage	368	0214	402
4	light sage/sage green mix	368/320	0214/0215	403

Optional outline

	DMC	ANCHOR	APPLETON
Flowers	939	0152	852
Leaves	320	0215	354

STITCH COUNT:
40 x 32

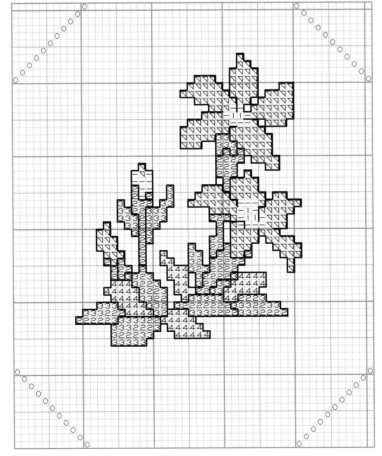

SPEEDWELL

The pretty Speedwell can be seen in the Flower Trellis rug on page 23, and the shawl on page 41. To calculate the design size for a project refer to the instructions on page 110.

SPEEDWELL

		DMC	ANCHOR	APPLETON
☑	medium green	502	0877	643
☒	dark green	501	0878	645
◪	bright blue	798	0131	464
✳	bright coral	891	029	864
⊡	yellow	744	0301	471
Optional outline				
Flowers		798	0131	464
Leaves		501	0878	645

STITCH COUNT:
29 x 39

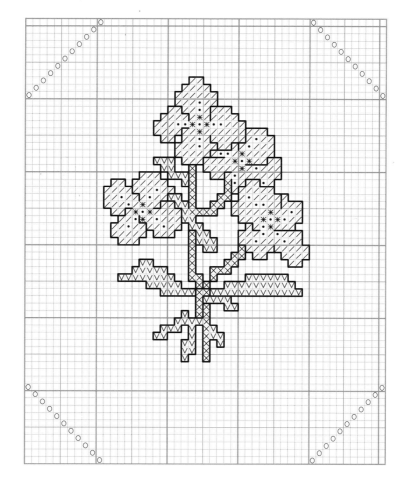

FLOWERY AFGHAN SHAWL

This lavish shawl includes thirteen of the cottage garden flowers, stitched in alternate squares on a beautiful Afghan fabric (see diagram below). Before choosing the flower designs from the charts in this book, check the stitch count on each flower and the thread count on the Afghan fabric you have selected. These products are generally divided into squares and it is important to check that the designs you have selected will fit. (Refer to page 109 for tips on buying Afghan fabric.) To stitch the Afghan as seen in the colour picture, you will need to refer to the charts listed in the stranded cotton requirements given below.

You may sometimes find it necessary to adapt a design to suit an Afghan project, for example by omitting part of a flower to improve the shape or balance within a square (see the Columbine opposite). Similarly, if the finished project is intended for more than decoration, you may decide to omit long stitches, which might catch on furnishings (see the Rhododendron opposite).

Afghan shawl with 25 squares plus fringe, 15-count (for suppliers, see page 126)
Stranded cottons (floss) as listed on the following flower charts – Poppy (page 11), Fuchsia (page 16), Columbine (page 29), Briar Rose (page 32), Flax (page 33), Bindweed (page 36), Daisy (page 37), Gentian (page 38), Speedwell (page 39), Iris (page 42), Rhododendron (page 43), Dandelion (page 46) and Mallow (page 47)
Size 24 tapestry needle

NOTE You may need to purchase extra skeins of some of the colours (especially the greens), depending on your choice of flowers and the amount of outlining you decide to do.

1 When you begin an Afghan project, either machine or sew a line of running stitches around the first pattern division to prevent the fabric fraying during stitching and also to act as a barrier when the raw edge is frayed after the project has been completed.
2 Before starting to stitch, each square or section must be centred, to ensure the correct positioning of each motif. Lay the Afghan fabric on a clean flat surface and mark with a pin the squares that are to be stitched (see diagram on this page). Each square should then be treated as a separate project, so find its centre; mark with lines of tacking (basting) stitches and start the cross stitch from the centre.
3 The shawl seen here was stitched using four strands of stranded cotton (floss) for the cross stitch. The back stitch outline has been omitted on the leaves and stems but included on the flowers, using two strands only.
4 When the cross stitch and back stitch is complete, the edge of the shawl may be frayed by simply removing threads back to the line of machine or hand stitching.

Rhodo-dendron		Bindweed		Iris
	Flax		Mallow	
Speedwell		Fuchsia		Daisy
	Briar Rose		Dandelion	
Poppy		Gentian		Columbine

Placement diagram for the flowers on our Afghan; you may prefer to work another selection

(Opposite) Flowery Afghan Shawl

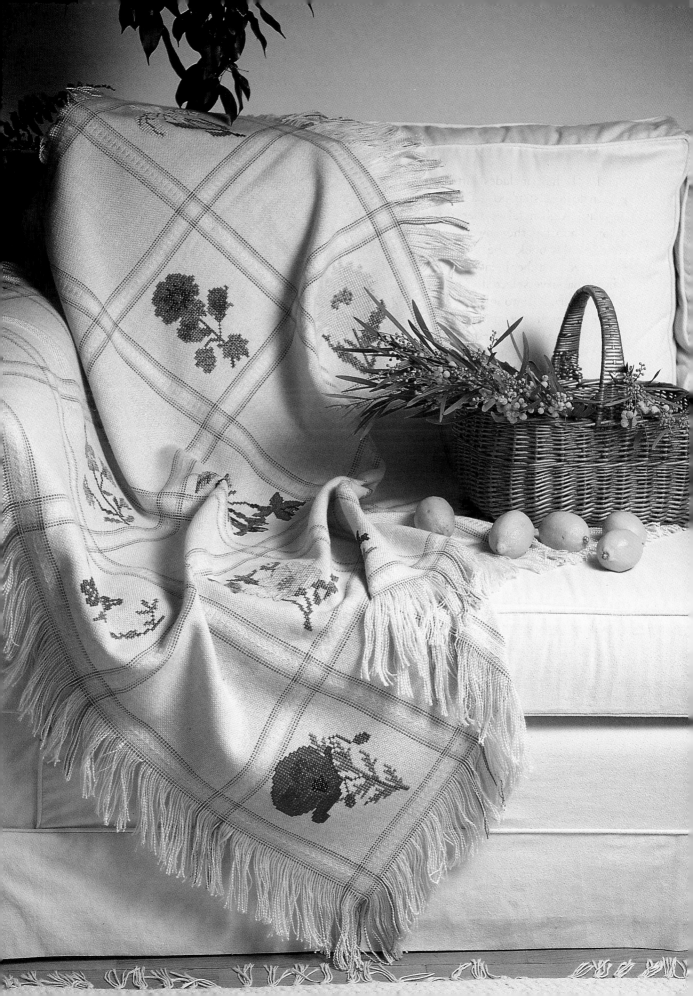

IRIS

The graceful Iris can be seen in the Flower Trellis rug on page 23, the shawl on page 41, the sewing tidy on page 45, the silk miniature on page 53, and the cross stitch bell pull on page 51. To calculate the design size for a project refer to the instructions on page 110.

IRIS

		DMC	ANCHOR	APPLETON
⊠	drab mauve	3041	0871	603
⧄	bright yellow	744	0301	471
⊡	pale lemon	677	0300	872
⊞	cream	712	0926	882
⊠	dark green	367	0216	403
⊻	light green	368	0214	402
▲	very dark green	319	0217	405

Optional outline

Petals	3041	0871	603
Leaves	319	0217	405

STITCH COUNT:
36 x 49

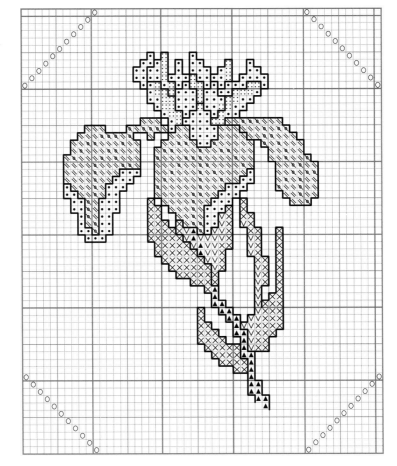

RHODODENDRON

The Rhododendron can be seen in the Flower Trellis rug on page 23, the shawl on page 41, the sewing tidy on page 45, and the cross stitch picture on page 51. To calculate the design size for a project refer to the instructions on page 110.

RHODODENDRON

	DMC	ANCHOR	APPLETON
☒ dark green	986	0246	405
⩗ medium green	988	0243	544
⊡ pale pink	818	048	941
⊞ cream	712	0926	882
◉ rich red	355	0341	226
⧅ pink	3326	036	943

Optional outline

Petals & stamen	355	0341	226
Leaves	986	0246	405

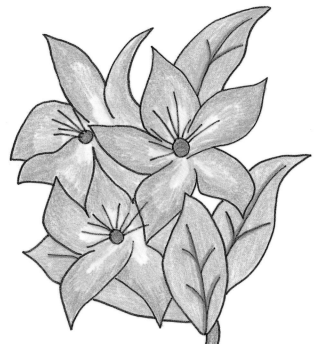

STITCH COUNT:
40 x 50

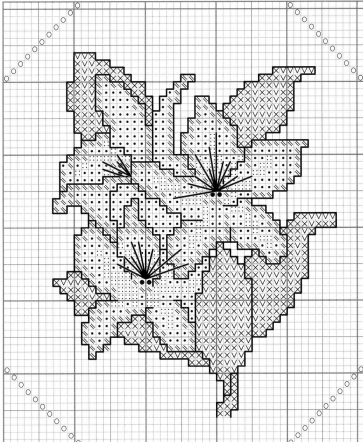

43

CANVASWORK SEWING TIDY

This is really a pincushion with a pocket hanging on each side! The stand on which it is mounted is an old wool bobbin that we found in a very dirty state in a junk shop. Once cleaned and waxed it was just right for the sewing tidy and seemed most appropriate, as it must have come from a wool mill. A modern candle stick or a lamp base would be suitable if, unlike us, you do not take every opportunity to spend a happy morning browsing in the antique shops. The quantities given below are those required for using the Rhododendron design for the pincushion and Iris, Bindweed, Mallow and Orchid on the pockets. You may prefer another selection of flowers, in which case you will need one skein of each colour listed with the instructions for each flower. Where a colour is repeated with two different charts you need only purchase one skein, as you will not need as much as two skeins to complete both your chosen designs.

Five 8 x 8 inch (20 x 20cm) squares of 14-count canvas
One skein each of Appleton crewel wools in the following colours: 106, 202, 205, 226, 402, 403, 405, 471, 472, 544, 603, 643, 645, 711, 714, 872, 881, 882, 941, 943, 945, 946 and 948
Two hanks of 926 for the background
Size 22 tapestry needle
Masking tape
20 inches (50cm) of lightweight fabric for backing and lining

**Three strands of crewel are used throughout
Stitches used: tent stitch, diagonal tent stitch and
long-legged cross stitch (see pages 116–17)**

1 Take one square of canvas and bind the edges with masking tape. Fold the canvas in four to find the centre, and mark the folds with pencil lines. Following the chart on page 43 and starting at the centre, stitch the Rhododendron, using tent stitch.
2 Draw a 5 inch (13cm) square on the canvas, centring the completed Rhododendron, and fill this area with diagonal tent stitch in the background colour.
3 Work a row of long-legged cross stitch to surround the background area.
4 Repeat for each of the other four flowers.
5 Refer to page 117 for stretching and to page 124 for making-up instructions.

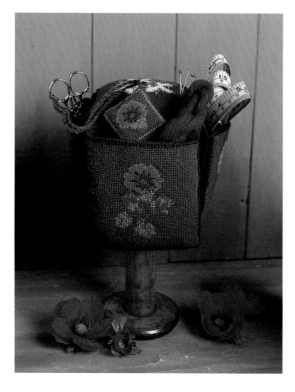

The Canvaswork Sewing Tidy in use (left), and laid flat (opposite) to show all the pockets

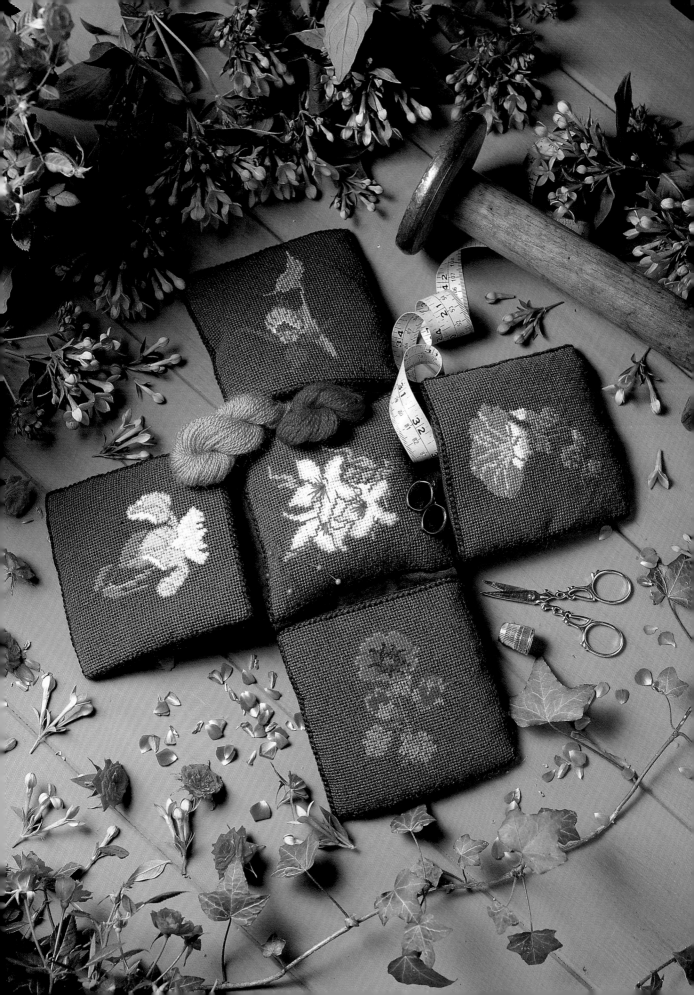

DANDELION

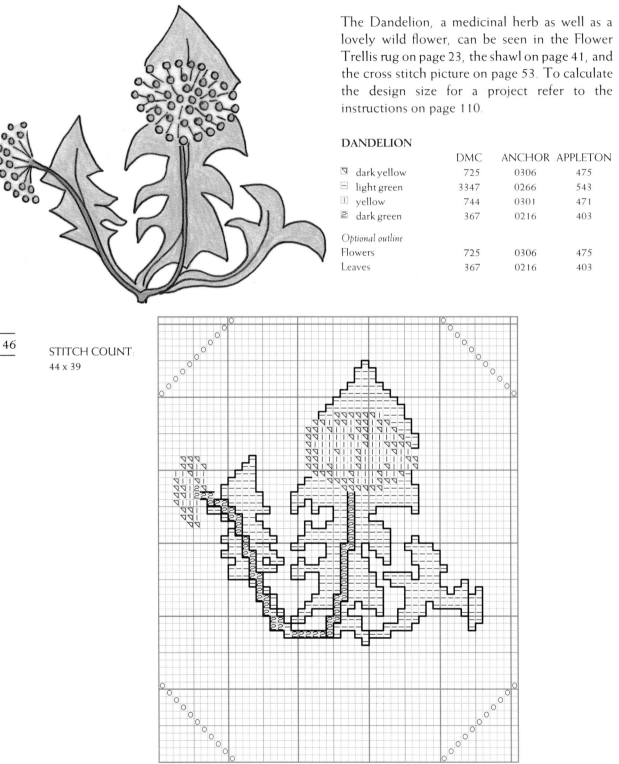

The Dandelion, a medicinal herb as well as a lovely wild flower, can be seen in the Flower Trellis rug on page 23, the shawl on page 41, and the cross stitch picture on page 53. To calculate the design size for a project refer to the instructions on page 110.

DANDELION

		DMC	ANCHOR	APPLETON
◪	dark yellow	725	0306	475
▦	light green	3347	0266	543
▥	yellow	744	0301	471
▨	dark green	367	0216	403
Optional outline				
Flowers		725	0306	475
Leaves		367	0216	403

STITCH COUNT:
44 x 39

MALLOW

The Mallow can be seen in the Flower Trellis rug on page 23, the shawl on page 41, the sewing tidy on page 45, and the scissor keeper on page 53. To calculate the design size for a project refer to the instructions on page 110.

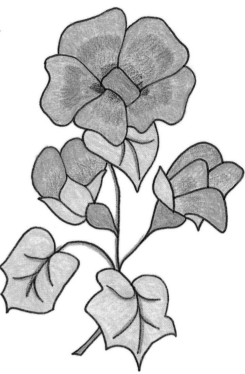

MALLOW

		DMC	ANCHOR	APPLETON
◪	dark pink	3685	069	948
⊟	very dark blue	939	0152	106
⊡	dusty pink	3350	065	946
☑	rose pink	3687	068	945
◸	sage green	502	0877	643
◺	dark sage	501	0878	645

Optional outline

Flowers	3687	068	945
Leaves	501	0878	645

STITCH COUNT:
48 x 35

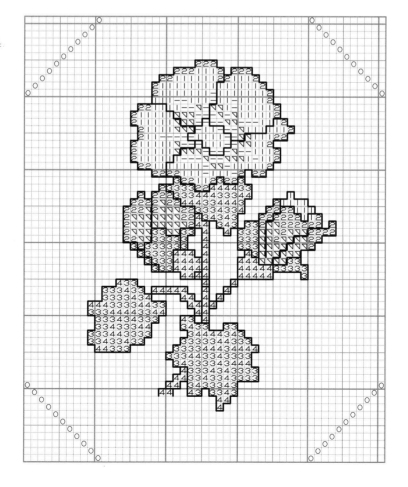

CANTERBURY BELL

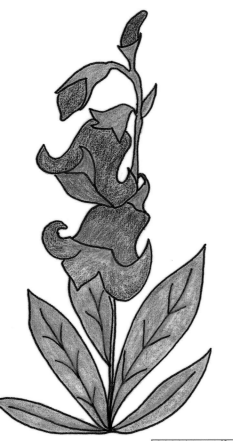

This lovely wild flower can be seen in the Flower Trellis rug on page 23, and the cross stitch bell pull on page 51. To calculate the design size for a project refer to the instructions on page 110.

CANTERBURY BELL

		DMC	ANCHOR	APPLETON
5	dark green	367	0216	403
⊟	light green	368	0214	402
3	medium green	320	0215	354
⊠	violet blue	340	0118	894
⊠	pale blue	341	0117	892
2	mauve	3746	0119	896

Optional outline

Flowers	797	0132	824
Leaves	367	0216	403

STITCH COUNT:
30 x 58

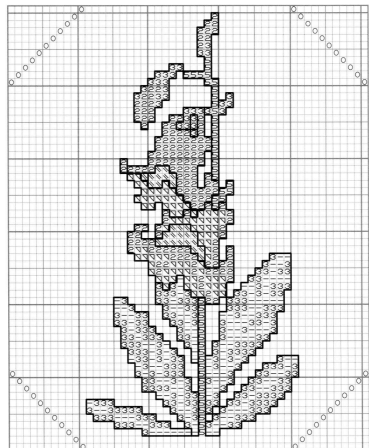

PERIWINKLE

This charming Periwinkle can be seen in the Flower Trellis rug on page 23, and the canvaswork key fob on page 53; it is also one of the quartet of flowers on page 51. To calculate the design size for a project refer to the instructions on page 110.

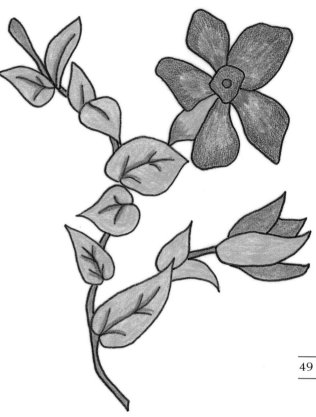

PERIWINKLE

		DMC	ANCHOR	APPLETON
⊡	light blue	341	0117	892
⋓	dark green	367	0216	403
⊞	light green	368	0214	402
⊠	violet blue	340	0118	894
⊟	old gold	729	0890	695
⊟	dark blue	792	0177	896

Optional outline

Flowers	792	0177	896
Leaves	367	0216	403

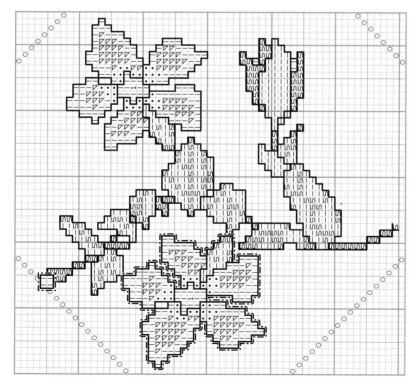

STITCH COUNT:
56 x 53

QUARTET OF FLOWERS
IN CROSS STITCH

The beautiful colour picture opposite illustrates the versatility of cross stitch charts and, in particular, these simple flower designs. The Mallow, Bindweed, Rhododendron and the Periwinkle are all featured in the rug on page 23 and yet make equally striking projects when framed in these co-ordinating triple mounts. The flowers were stitched on identical linen to make a delightful group, but they would also look attractive on coloured Aida fabric, if you prefer. Feel free to select any four of the flower charts for your own quartet, possibly matching the colours of the flowers to those of the furnishings or decoration of your own home. If you wish to reproduce the examples illustrated opposite, you will need the charts on pages 36, 43, 47 and 49. If you are not sure where to start, refer to page 112 for instructions.

FLOWER BELL PULL

This unusual project may be finished as a bell pull or framed within a double mount, as illustrated opposite. The cross stitch is worked on linen band; this is self-hemmed and does not require finishing, except at the top and bottom, which makes it ideal for bell pulls. The design opposite includes Flax, Canterbury Bell, Sweetpea, Orchid and Iris, but again feel free to select your own favourites.

31½ inches (80cm) of half-bleached 28-count linen band, 4 inches (10cm) wide, with a decorative edge
(for suppliers, see page 126)
Stranded cottons (floss) as listed on
pages 28, 33, 42, 48, and 52
Size 26 tapestry needle

1 Cut a piece of linen band 31½ inches (80cm) long and work a narrow hem across the two short edges to prevent fraying. Fold the linen band in half lengthwise and mark the fold with a line of tacking (basting) stitches.
2 Set the linen aside while you select the flower designs you wish to use. Choose the flower to be positioned in the middle of the linen band and, following the chart, work from the centre using two strands of stranded cotton (floss) for the cross stitch, and one strand for the (optional) back-stitch outline, and working over two threads of the linen fabric.
3 Add more flower motifs, leaving a gap between each flower. In the example illustrated, there are 13 stitch spaces above and below each motif. Refer to the individual charts for details of suggested outline colours.
4 Check for missed stitches, then finish the piece by adding bell pull ends or framing the design, as preferred.

(Opposite) The Quartet of Flowers and Flower Bell Pull

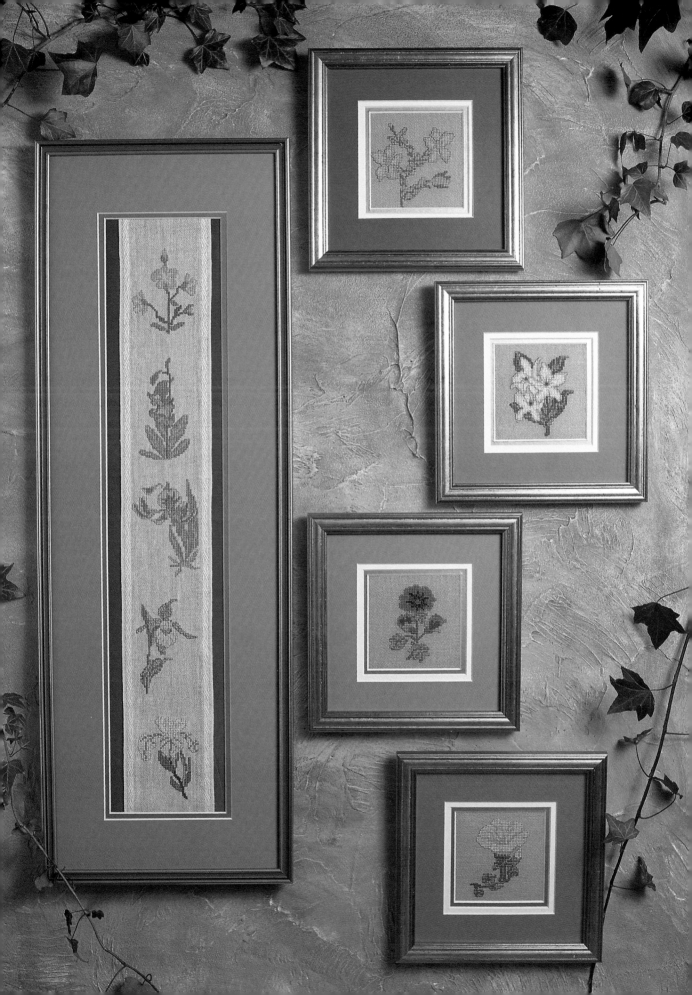

ORCHID

The beautiful Orchid can be seen in the Flower Trellis rug on page 23, the sewing tidy on page 45, the cross stitch bell pull on page 51, and the scissor case featured opposite. To calculate the design size for a project refer to the instructions on page 110.

ORCHID

		DMC	ANCHOR	APPLETON
☑	yellow	744	0301	472
⊟	cream	712	0926	882
▨	lilac pink	778	0968	711
▨	light green	368	0214	403
▨	dark green	367	0216	402
⊞	pink/brown mix	315/778	0896/0968	714

Optional outline

Flowers	315	0896	714
Leaves	368	0214	403

STITCH COUNT:
36 x 55

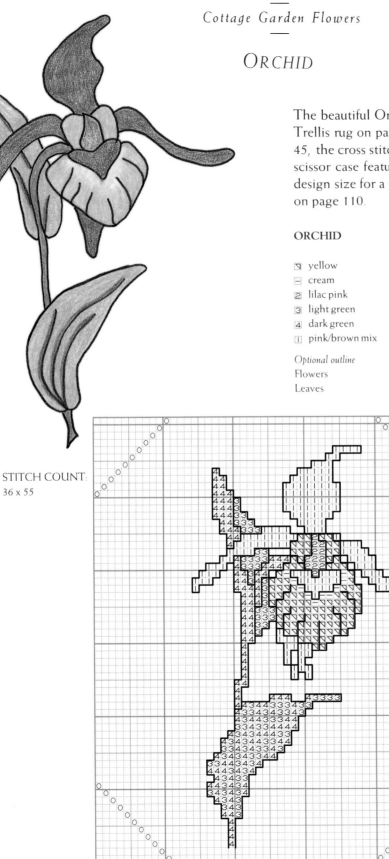

A selection of small projects are pictured opposite to give you some ideas

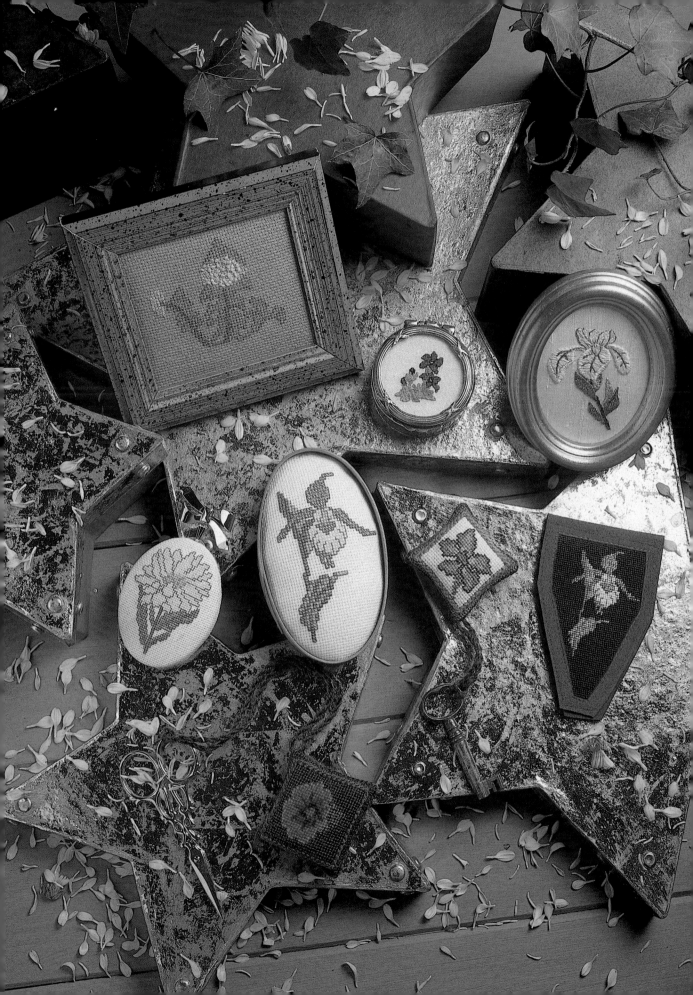

CHAPTER TWO

High tea

We were both little girls in the fifties and this chapter has a nostalgic feeling for us. Remember all those embroidered tray cloths and napkins lovingly stowed away in lavender-scented drawers by doting grannies? Although not strictly floral, the notion of the tea table covered and surrounded by all these pretty things was too hard to resist.

The Hollyhock Cottage picture in the background was based on the outline drawing used for the tea cosy on the tea table. The egg cosies are two small morsels of the tea cosy design and the flowers on the napkins have just been gathered by the flower girl in the picture! She has also been adapted and repeated on her own in the smaller frame.

Hollyhock Cottage Tea Cosy (see page 56); two Egg Cosies (see page 60); Napkins (see page 61); Hollyhock Cottage Cross Stitch Picture (see page 62) and the Flower Girl (see page 67)

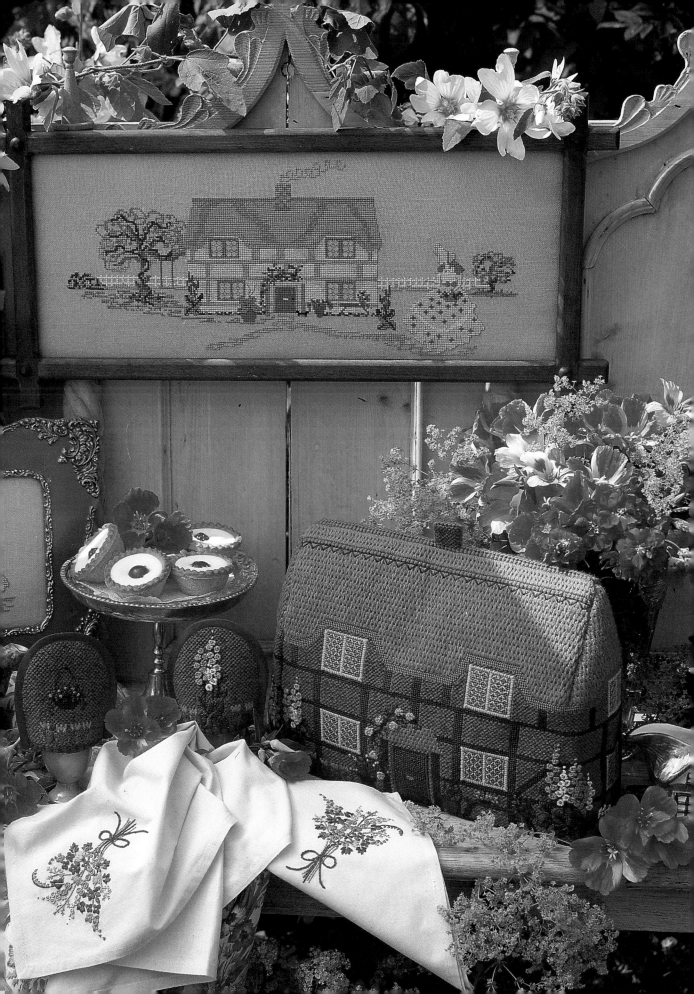

HOLLYHOCK COTTAGE TEA COSY

FINISHED SIZE: 11 inches wide x 9½ inches high
x 5 inches deep (28 x 24 x 12.5cm)

39 x 16 inches (100 x 40cm) of 14-count canvas
Appleton crewel wools as listed below
Size 22 tapestry needle
Black waterproof felt-tip pen
A3 size sheet of tracing paper
Masking tape
Embroidery frame
12 x 36 inches (30 x 90cm) of polyester
wadding/batting and the same of felt, for lining

**For the number of strands used refer to the diagram on
pages 58–9**
Stitches used: tent, gobelin, long-and-short, split back,
satin, cross, buttonhole, bullion knots, French knots and
long-legged cross (see pages 116–17 and 119–21)

1 If you are not using a transfer (see page 127)
trace the enlarged outline of the cottage on
pages 58–9 on the tracing paper, using the felt-
tip pen. Place the tracing on a flat surface and
secure it with masking tape (you may find it help-
ful to lay a plain sheet of white paper under the
tracing to make the lines show up better).

2 Lay the left-hand end of the long piece of can-
vas over the tracing ensuring that the horizontal
and vertical lines of the cottage follow the
threads of the canvas and leaving a margin of
1 inch (2.5cm) on the left-hand side and at the
top and bottom edges.

3 Using the waterproof pen (it must be water-
proof so that when you stretch the finished piece
the pen marks will not run and spoil your em-
broidery) draw on the canvas all the lines of the
cottage, which you will be able to see quite
clearly through the canvas.

4 Move the canvas along and secure it again, so
that the right-hand side of the completed part of
the tracing becomes the left-hand side of the
next tracing. Repeat the drawing. Your canvas
should now look a bit like a row of cottages!

5 Mount the prepared canvas on to your em-
broidery frame. Following the instructions given
on the key to the drawing (pages 58–9) for
stitches and colours, and referring to pages
116–17 and 119–21 for details of the stitches
used, work all the details first, followed by the
brown timbers.

6 Finally, fill in the red brick background and
the thatched roof. (The design repeat forms the
back and second side of the tea cosy.)

7 When your stitching is complete turn to page
117 for stretching and to page 124 for
making-up instructions.

TEA COSY AND EGG COSIES

	APPLETON	QUANTITIES
light brick red	721	2 hanks
dark brick red	725	1 hank
dark brown	976	1 hank
grey	964	3 skeins
fawn	971	2 skeins
very pale gold	691	2 skeins
dark green	358	2 skeins
mid-green	546	4 skeins
pale green	355	2 skeins
dark straw	903	2 hanks
pale straw	902	2 hanks
bright red	866	1 skein
pink	222	1 skein
pale pink	221	1 skein
brown	305	2 skeins
pale yellow	472	1 skein
yellow	474	1 skein
blue	925	1 skein
mauve	605	1 skein
cream	882	1 skein
charcoal black	998	1 skein

NOTE No DMC or Anchor equivalents are given for this
project, as it will only work in wool; the above quantities are
sufficient for the tea cosy and both egg cosies.

*(Opposite) Hollyhock Cottage Tea Cosy, Egg Cosies
(see page 60) and Napkins (see page 61)*

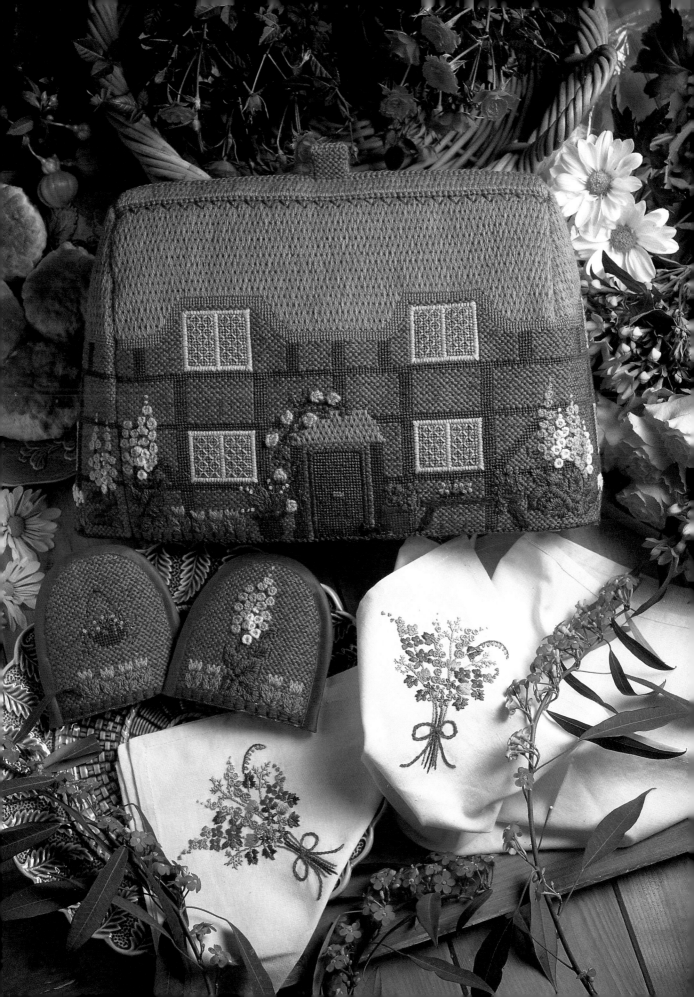

(721)3
(725)2 } A

(903)3E

(902)2
(903)2 } A over 6 threads

(903)3E

Back stitch detail (976)2 worked
over the gobelin thatch

(902)2
(903)2 } A over 6 threads

IMPORTANT
In order to fit this drawing on to the page it has been reduced
in size to 90%. You will need to take it to your nearest
photocopiers and ask for it to be enlarged accordingly

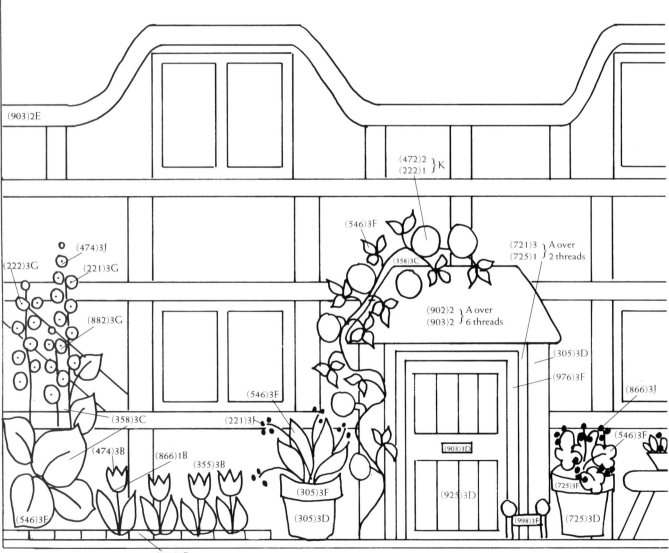

(903)2E

(472)2
(222)1 } K

(546)3F

(358)3C

(721)3
(725)1 } A over 2 threads

(474)3J

(222)3G

(221)3G

(882)3G

(902)2
(903)2 } A over 6 threads

(305)3D

(976)3F

(866)3J

(358)3C

(546)3F

(221)3J

(546)3F

(474)3B

(866)1B

(355)3B

(903)3D

(725)3F

(925)3D

(305)3F

(546)3F

(305)3D

(998)3F

(725)3D

(725)3F

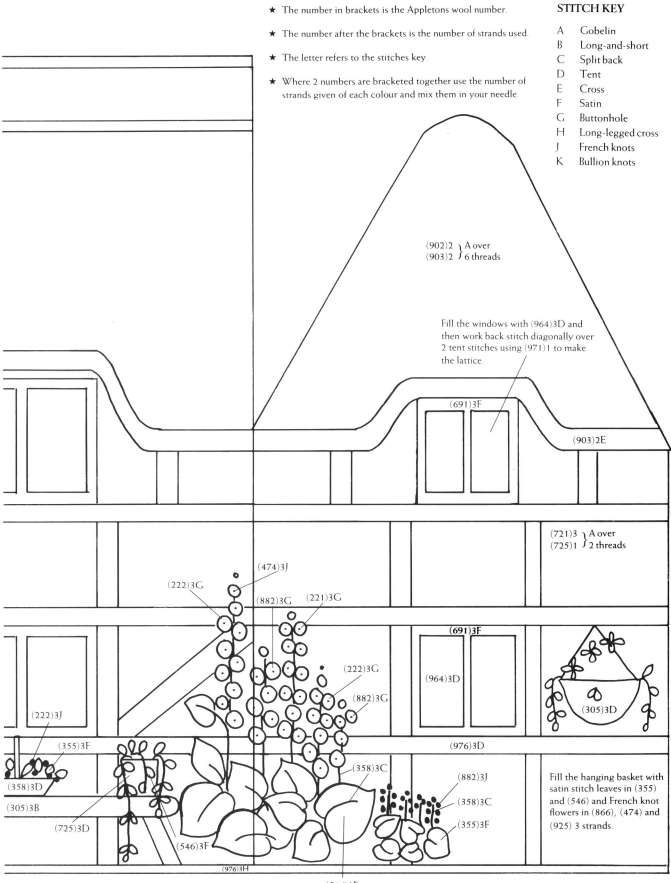

★ The number in brackets is the Appletons wool number.

★ The number after the brackets is the number of strands used.

★ The letter refers to the stitches key.

★ Where 2 numbers are bracketed together use the number of strands given of each colour and mix them in your needle.

STITCH KEY

A Gobelin
B Long-and-short
C Split back
D Tent
E Cross
F Satin
G Buttonhole
H Long-legged cross
J French knots
K Bullion knots

(902)2 } A over
(903)2 } 6 threads

Fill the windows with (964)3D and then work back stitch diagonally over 2 tent stitches using (971)1 to make the lattice.

(691)3F

(903)2E

(721)3 } A over
(725)1 } 2 threads

(474)3J

(222)3G

(882)3G (221)3G

(222)3G

(882)3G

(691)3F

(964)3D

(305)3D

(222)3J

(976)3D

(355)3F

(358)3D

(305)3B

(725)3D

(546)3F

(358)3C

(882)3J

(358)3C

(355)3F

Fill the hanging basket with satin stitch leaves in (355) and (546) and French knot flowers in (866), (474) and (925) 3 strands.

(976)3H

(546)3F

HOLLYHOCK COTTAGE EGG COSIES

These two amusing little egg cosies seem to fit the rather old-fashioned feel of this chapter very well. They are worked from yarns left-over from the tea cosy, and the designs are fragments of the main design. If you want to make more cosies when you have completed these two, you could easily trace other parts of the tea cosy design to make a varied set. Refer to the tea cosy (pages 56–9) for the colour and stitch keys, and for tracing and stitching instructions. Refer to page 117 for stretching and to page 122 for making up.

For colour key see page 56, and for stitch keys see page 59.

60

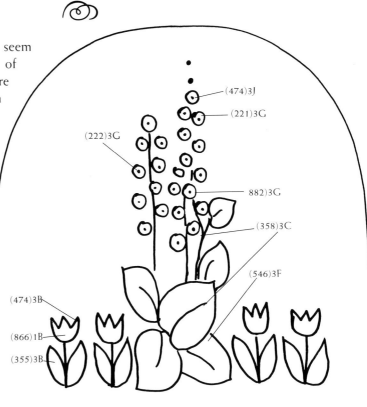

For two egg cosies you will need:
12 x 8 inches (30 x 20cm) of
14-count canvas
Appleton crewel wools left over
from the tea cosy
Size 22 tapestry needle
Black waterproof felt-tip pen
Sheet of tracing paper
Masking tape
Embroidery frame
12 x 12 inches (30 x 30cm) of felt
for lining and backing
39 inches (100cm) of satin binding,
¾ inch (2cm) wide

To fill the hanging basket see the note on page 59.

HOLLYHOCK COTTAGE TABLE NAPKINS

The embroidery on these napkins is not crewel embroidery, but stitch instructions on pages 119–21 apply equally well to this type of surface embroidery and so we felt able to include them, especially as they completed our tea table so beautifully. The napkins shown were purchased ready-made in fine cotton; Irish linen would also be a very suitable fabric. The quantities of stranded cotton (floss) given will be sufficient for up to eight napkins, if you wish to make a set.

Ready-made napkins
One skein each of the stranded cottons (floss) listed below
Size 7 crewel needle
6 inch (15cm) embroidery hoop or small frame
Water-soluble pen
Black felt-tip pen
Sheet of tracing paper

Two strands of stranded cotton (floss) are used throughout
Stitches used: long-and-short, stem, chain, buttonhole, satin, lazy daisy and French knots (see pages 119–21)

1 Trace the outline on to the corner of each napkin, following the instructions given for the crewelwork Poppy on page 12.
2 Embroider the design, following the key below for the use of colours and stitches, and referring to pages 119–21 for stitch instructions.
3 When the embroidery is complete, rinse the napkin gently in hand-hot water to remove the water-soluble pen lines.
4 Cover your ironing board with a thick, soft white towel, and iron the napkins on the wrong side while still damp.

61

STITCH KEY

A Lazy daisy
B Long-and-short
C Chain
D Stem
E Satin
F Buttonhole
G French knots

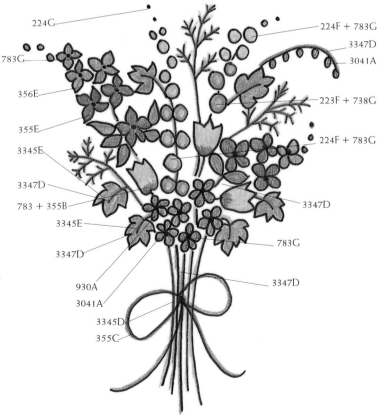

TABLE NAPKIN

	DMC	ANCHOR
dark pink	223	0895
pale pink	224	0893
yellow	783	0307
mauve	3041	0871
dark coral	355	0341
pale coral	356	5975
dark green	3345	0268
pale green	3347	0266
blue	930	0922

HOLLYHOCK COTTAGE

This charming picture was based on the outline drawing for the tea cosy on page 57. The colours have been changed to suit the more delicate effect of cross stitch on linen. Although not shown, the same design would also look quite delightful worked in tent stitch on canvas, either as a cushion or a picture. For this reason, we have given Appleton equivalents, but if you work the picture on canvas you will also have to choose a suitable background colour.

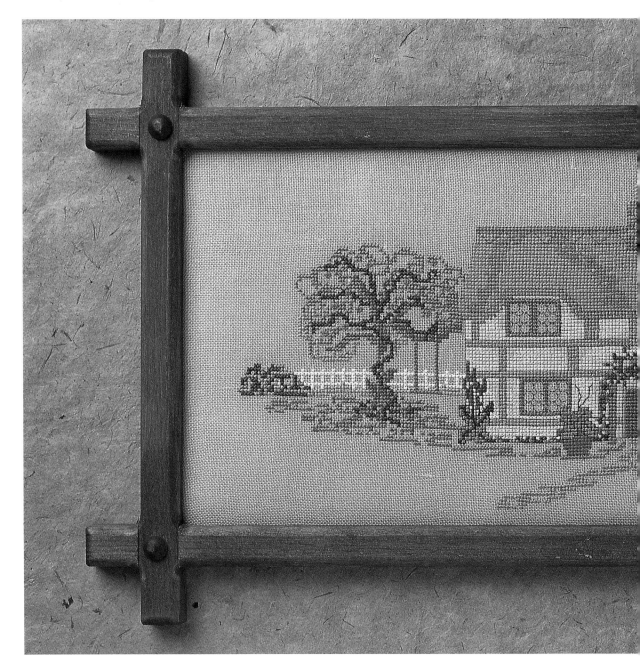

DESIGN SIZE: 16½ x 7 inches (42 x 18cm)
STITCH COUNT: 243 x 102

24 x 11 inches (60 x 27.5cm) of 28/29-count linen
in champagne
Stranded cottons (floss) listed on the chart
Size 26 tapestry needle

1 Sew a narrow hem around the edge of the linen to prevent fraying. Fold the fabric in four and mark the folds with tacking (basting) stitches.

2 Following the chart, work the cross stitch, starting in the centre and using two strands of stranded cotton (floss) for the cross stitch and one for the backstitch outline.

3 When the embroidery is complete, check for missed stitches and mount and frame as preferred (see pages 113–14).

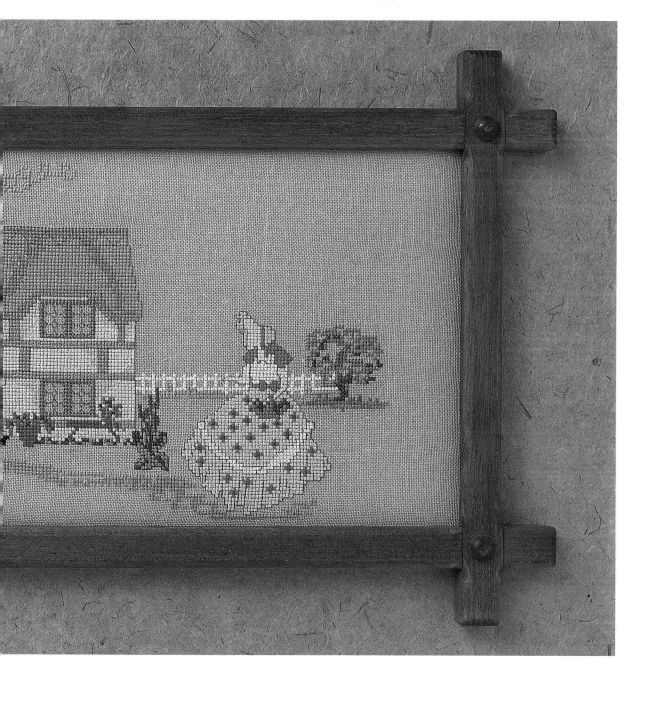

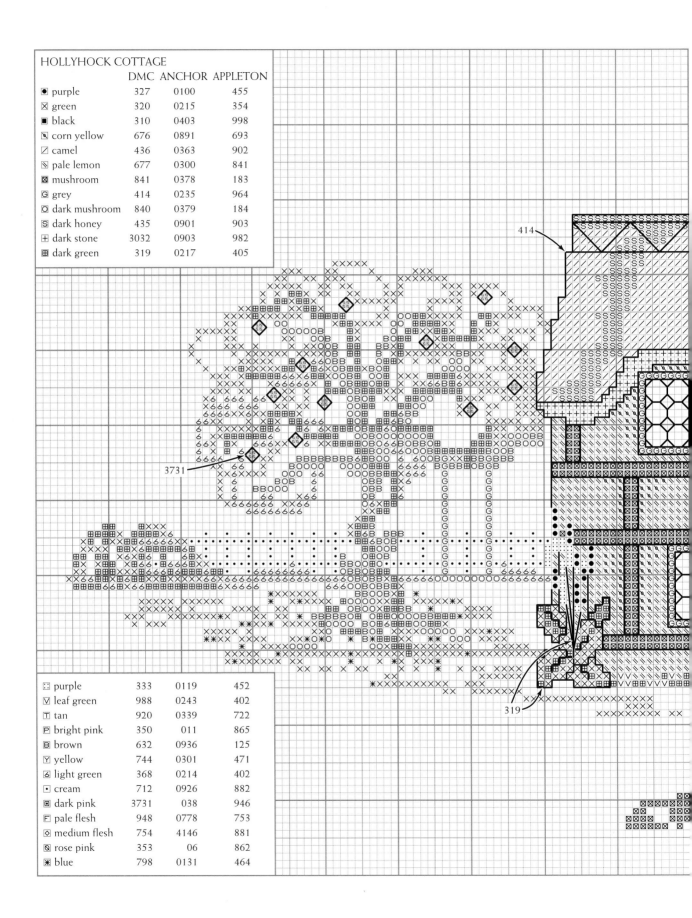

HOLLYHOCK COTTAGE

		DMC	ANCHOR	APPLETON
⊙	purple	327	0100	455
⊠	green	320	0215	354
▣	black	310	0403	998
◪	corn yellow	676	0891	693
◩	camel	436	0363	902
◨	pale lemon	677	0300	841
⊠	mushroom	841	0378	183
G	grey	414	0235	964
O	dark mushroom	840	0379	184
S	dark honey	435	0901	903
⊞	dark stone	3032	0903	982
⊞	dark green	319	0217	405

414

3731

319

⊡	purple	333	0119	452
Ⅵ	leaf green	988	0243	402
Ⅱ	tan	920	0339	722
ℙ	bright pink	350	011	865
ℬ	brown	632	0936	125
Ⅶ	yellow	744	0301	471
6	light green	368	0214	402
⊡	cream	712	0926	882
▣	dark pink	3731	038	946
ℙ	pale flesh	948	0778	753
⊠	medium flesh	754	4146	881
◨	rose pink	353	06	862
✳	blue	798	0131	464

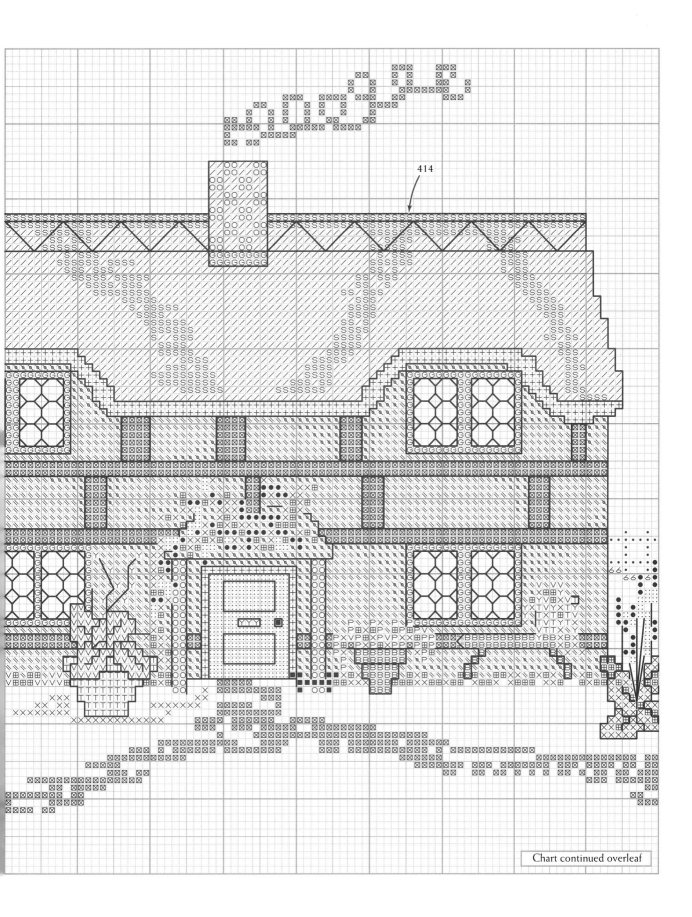

414

Chart continued overleaf

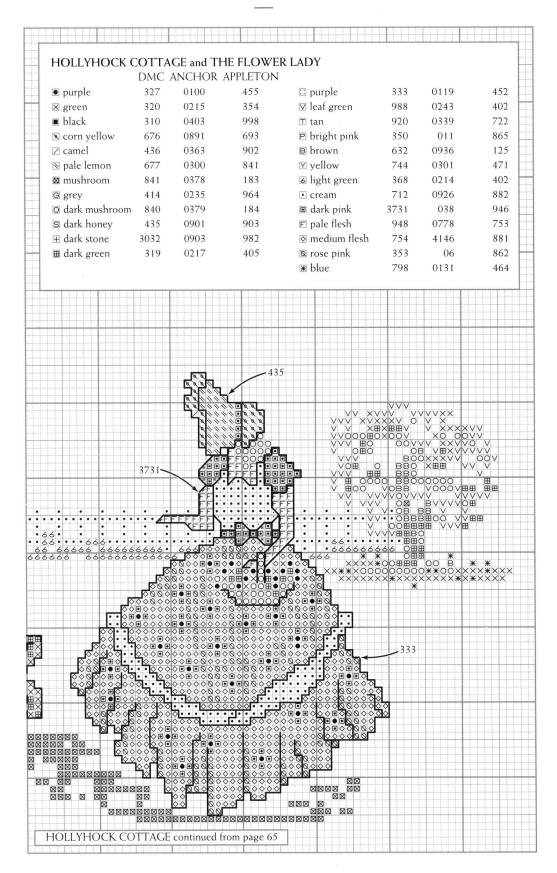

HOLLYHOCK COTTAGE and THE FLOWER LADY

DMC ANCHOR APPLETON

● purple	327	0100	455	
⊠ green	320	0215	354	
■ black	310	0403	998	
◣ corn yellow	676	0891	693	
⊿ camel	436	0363	902	
◩ pale lemon	677	0300	841	
⊠ mushroom	841	0378	183	
ᏻ grey	414	0235	964	
◎ dark mushroom	840	0379	184	
◫ dark honey	435	0901	903	
⊞ dark stone	3032	0903	982	
⊞ dark green	319	0217	405	

⊟ purple	333	0119	452
☑ leaf green	988	0243	402
⊤ tan	920	0339	722
ℙ bright pink	350	011	865
Ⓑ brown	632	0936	125
⅄ yellow	744	0301	471
ẟ light green	368	0214	402
⊡ cream	712	0926	882
⊡ dark pink	3731	038	946
Ⅎ pale flesh	948	0778	753
⊠ medium flesh	754	4146	881
Ⓠ rose pink	353	06	862
✳ blue	798	0131	464

435

3731

333

HOLLYHOCK COTTAGE continued from page 65

THE FLOWER GIRL

The girl was lifted from the Hollyhock Cottage picture. You may wish to add your own selection of motifs and flowers; if so, remember that the stitch count and dimensions given refer to our version, so you will have to check the dimensions of your variation in order to assess fabric requirements. Refer to the Hollyhock Cottage chart for stranded cottons (floss), but note that you will probably not require every colour listed in the key if you are only going to make this picture, or a variation of it.

DESIGN SIZE: 4½ x 5½ inches (11.5 x 14cm)
STITCH COUNT: 61 x 70

10 x 10 inches (25 x 25cm) of 28-count linen in eau-de-Nil
Stranded cottons (floss in those colours from the Hollyhock Cottage chart
Size 26 tapestry needle
Graph paper and a soft pencil

1 To reproduce the beautiful little picture of the Flower Girl as illustrated here and on page 55 you will need to plan your design before you start stitching. Using a soft pencil and graph paper, copy the outline of the Flower Girl and then add a selection of flower pots or plants in a pleasing arrangement. It is not necessary to copy all of the chart because, when you are satisfied with the position of the motifs, you may stitch the detail from the picture.
2 Our example was stitched using two strands of stranded cotton (floss) for the cross stitch and one strand for the back stitch outline.
3 When the cross stitch is complete, check for missed stitches and mount and frame as preferred (see pages 113–14).

67

We have added a pretty hand-painted frame to the Flower Girl

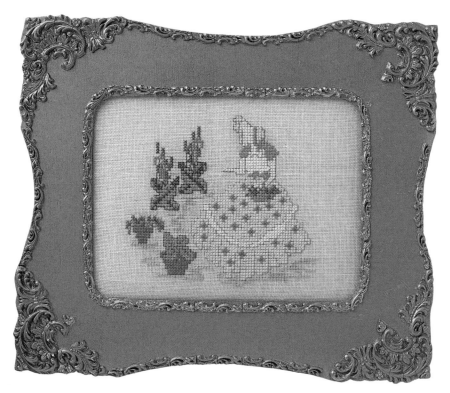

CHAPTER THREE

Woolworks

The canvaswork panels featured in this chapter are a combination of very simple crewel embroidery and canvaswork; as there was no established name for this type of embroidery, we have christened it woolwork. The free nature of true crewelwork seems to strike terror into the hearts of many stitchers, but as these designs are stitched on the canvas that is already familiar to most, we hope that they will seem less threatening, especially as the end results are so attractive. The softly shaded leaves and flowers seem to stand out in relief against the smooth background of the tent stitch. We have chosen a muted gold as the background colour and surrounded it with deep green linen furnishing fabric to make up the cushions. You could choose other colours to suit your own decor.

Strawberry Woolwork Cushion (see page 77) and
Strawberry Brooch Pillow (see page 75)

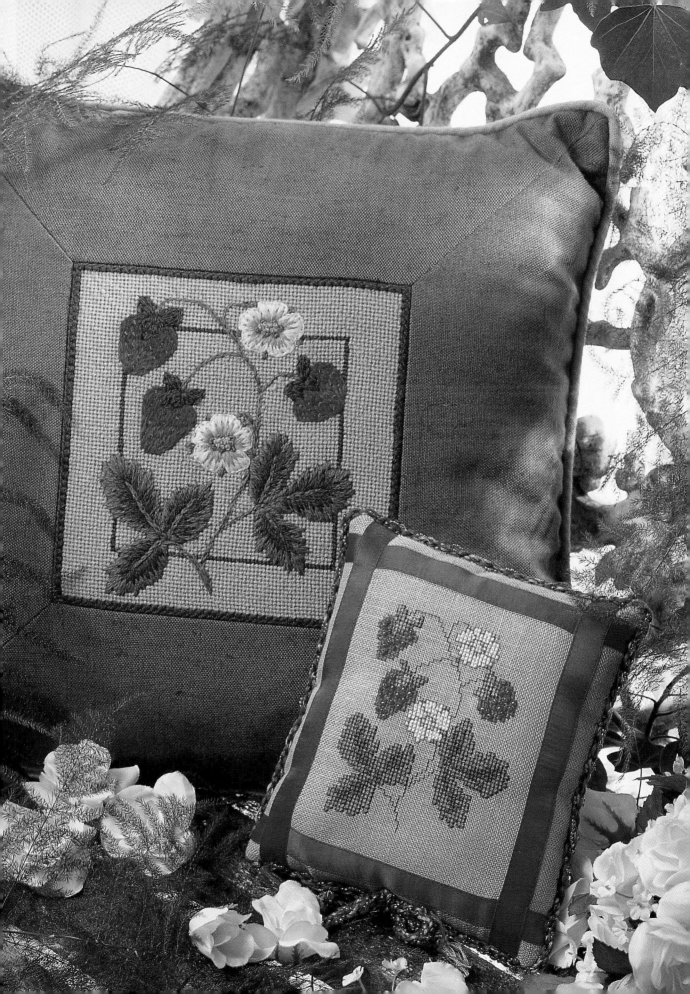

USING THESE DESIGNS

All the designs in this chapter begin with very simple outlines. In previous chapters we have shown how to trace outlines from charts; here we show that it is also possible to reverse the process and produce charts from line drawings. Once the outline has been traced on canvas and the simple crewelwork design has been completed, the remaining background is filled in with tent stitch. The embroidery takes on an almost three-dimensional effect, with the design standing out from the background.

As usual, we have included charts so that you may, if preferred, stitch these same designs in cross stitch. Some of our cross stitch versions have been embellished with beads and French knots, which give a three-dimensional effect to the embroideries that is akin to that of woolwork. Although we do not include pictures of any tent-stitched examples of the design, we have also listed Appleton crewel wool alternatives with the charts for those who would prefer plain tent stitch on canvas to woolworking.

STITCHING THE WOOLWORK DESIGNS

All the woolwork panels in this chapter are worked in the same way. Only the actual designs differ. Follow the general instructions on this page, and then refer to the specific instructions given with each line drawing.

For each panel you will need:
10 x 10 inches (25 x 25cm) of 14-count canvas
Appleton crewel wools, as listed with the line drawing for the design of your choice
Four skeins of Appleton crewel wool 692 for the background
Size 22 tapestry needle
Black waterproof felt-tip pen
Sheet of tracing paper
Masking tape
Embroidery frame

Three strands of crewel wool are used throughout unless otherwise stated in the text

Stitches used: tent stitch, diagonal tent stitch and long-legged cross stitch, long-and short stitch, satin stitch, split back stitch, French knots (see pages 116–17 and 119–21)

1 If you are not using a transfer (see page 127), trace the outline of the design you have chosen on to the tracing paper using a felt-tip pen.

2 Place the tracing on a flat surface and secure it with masking tape (you may find it helpful to lay a plain sheet of white paper under the tracing to make the lines show up better). Lay the square of canvas centrally over the tracing and secure with masking tape. Using the waterproof pen (it is important that this is waterproof so that when you stretch the finished piece the pen lines will not run), draw all the lines, which you will be able to see quite clearly through the canvas.

3 Before you start to stitch, it is a good idea to mark the lines for the edge of the tent stitch background and the inner borderline. Measure a 6 inch (15cm) square to surround the design and mark this on the canvas, using a fairly soft pencil. You will find that you can run the pencil in a groove of the canvas and that you do not need a ruler. To draw in the position of the inner line, count in 14 canvas threads from each edge and draw a pencil line. This line will cross the design in places; allow it to break off where this happens.

4 Turn to the specific instructions for the flower you have chosen, and embroider the entire design before you return to this page to complete the borders and background.

5 Using dark green, work a single row of tent stitch on the thread outside the inner pencil line.

6 Work the background in tent stitch, taking care to tuck the stitches under the long-and-short stitch and split back stitch of the design. We suggest that you work the area within the inner square and then the outer border.

7 Finally work a row of dark green long-legged cross stitch around the edge.

8 Refer to page 117 for stretching instructions and make up as preferred.

The woolwork design opposite has been partly worked to help you as you stitch. You will need to complete each part in the order given

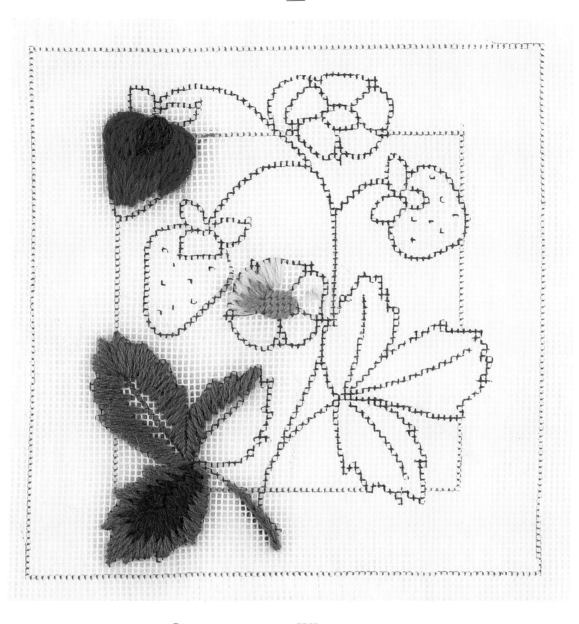

STRAWBERRY WOOLWORK

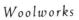

Refer to page 70 for general woolwork instructions before following the specific instructions below.

1 Begin the stitching with the leaves. Work the outer, paler layer of stitches first, taking the stitches into every canvas hole around the edges but changing the direction of the stitches as you work your way around the leaf by overlapping in the centre. Follow the outer line as well as you can to get a jagged effect (use the picture to help). You will find it easier to come up through the canvas on the outside and down towards the centre of the leaf. As you work the stitches, be aware of the direction of each thread that you lay on the canvas.

STRAWBERRY

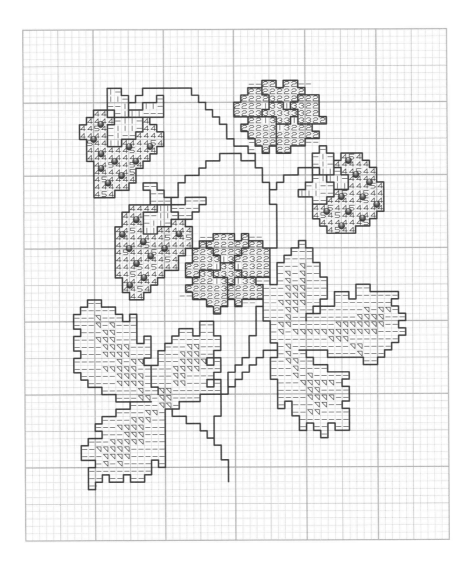

STRAWBERRY (CROSS STITCH)

		DMC	ANCHOR	APPLETON
◹	dark green	936	0846	245
⊟	leaf green	3346	0267	244
⊡	light green	3347	0266	242
2	cream	712	0926	882
3	yellow	744	0301	471
4	pinky red	309	042	502
5	red	304	047	504
Optional outline				
Leaves		936	0846	245
Strawberries		304	047	504
Flowers		3347	0266	242

2 Stitch the next layer in the darker shade, this time working from the centre of the leaf outwards. To blend the colours, you should take care that you split the threads of the previous layer of stitching.

3 To work the strawberries, use two shades of red: using long-and-short stitch, embroider the top two-thirds of each berry in dark red, then shade in the bottom third with pale red. Again, take care always to split the threads of the previous layer.

4 Embroider the small leaves in dark green.

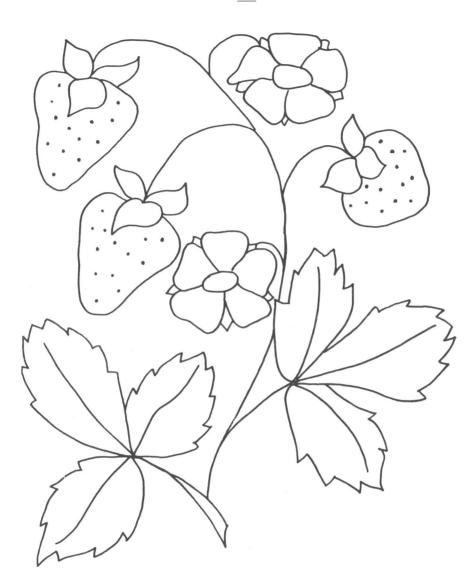

5 Using one strand of fawn, scatter several French knots randomly over each berry to represent the seeds.

6 Work the petals of the flowers in long-and-short stitch in cream and gold. The little spikes between the petals are in fawn. Make a cluster of French knots in gold in the centre of each flower, and surround it with a ring of fawn knots. The petals are outlined in split back stitch, using one strand only of cream.

7 Work the stems and leaf veins in split back stitch in pale green.

STRAWBERRY (WOOLWORK)

	APPLETON	NUMBER OF SKEINS
dark green	245	2
medium green	244	2
dark red	504	1
orange red	866	1
cream	882	1
fawn	912	1
gold	473	1

CHRISTMAS ROSE PICTURE

DESIGN SIZE: 3 ½ x 4 inches (9 x 10cm)
STITCH COUNT: 51 x 57

8 x 8 inches (20 x 20cm) of 28-count in linen,
tea coloured
Stranded cottons (floss) listed on the chart
on page 78
Size 24 tapestry needle
Purchased picture frame

1 Work a narrow hem around the edge of the linen to prevent fraying. Fold the fabric in four, press lightly and mark the folds with lines of tacking (basting) stitches.

2 Following the chart on page 78 and starting at the centre, stitch the Christmas Rose, using two strands of stranded cotton (floss) for the cross stitch. Add the back stitch after the cross stitch is complete, using one strand of the shade indicated on the chart (refer to pages 111-12 for more information).

3 When the stitching is complete, check for missed stitches and refer to page 113 for making-up instructions.

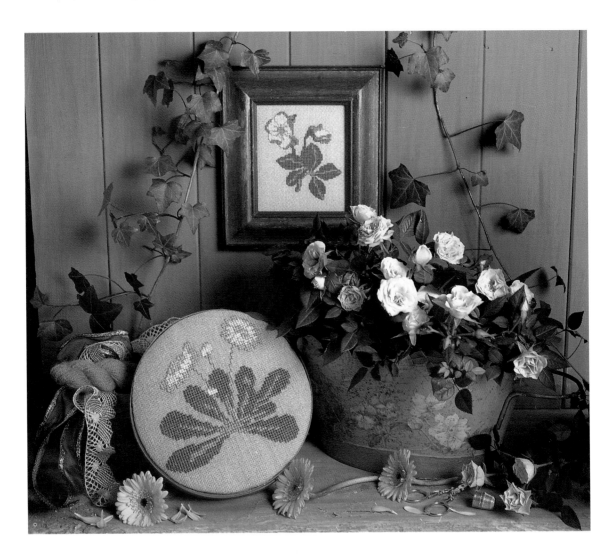

DAISY SHAKER BOX

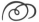

DESIGN SIZE: 6 x 5¾ inches (15 x 14cm)
STITCH COUNT: 59 x 57

12 x 12 inches (30 x 30cm) of 20-count natural linen
Stranded cottons (floss) listed on the chart on page 82
Size 24 tapestry needle
Purchased shaker box, 7½ inches (16cm) in
diameter (for suppliers, see page 126)

1 Before starting to stitch, check the dimensions of your box to ensure that the design will fit comfortably (see page 110).
2 Work a narrow hem around the edge of the linen to prevent fraying. This is important when using coarse linen as it can fray badly. Fold the fabric in four, press lightly and mark the folds with lines of tacking (basting) stitches.
3 Following the chart on page 82 and starting at the centre, stitch the daisy, using three strands of stranded cotton (floss) for the cross stitch. Add the back stitch after the cross stitch is complete, using two strands of the shade indicated on the chart (refer to pages 111–12).
4 When the stitching is complete, check for missed stitches and refer to the manufacturer's instructions for making-up.

STRAWBERRY BROOCH PILLOW

DESIGN SIZE: 3¼ x 4 inches (8 x 10cm)
STITCH COUNT: 47 x 54

8 x 8 inches (20 x 20cm) of 28-count in linen, sand coloured
Stranded cottons (floss) listed on page 72
Size 26 tapestry needle
40 small deep pink beads (optional)

1 Work a narrow hem around the edge of the linen to prevent fraying. Fold the fabric in four, press lightly and mark the folds with lines of tacking (basting) stitches.
2 Following the chart on page 72 and starting at the centre, stitch the strawberries, using two strands of stranded cotton (floss) for the cross stitch. Add the back stitch after the cross stitch is complete, using one strand of the shade indicated on the chart (refer to pages 111–12).
3 To add a three-dimensional effect, as seen in the picture, work a few French knots on top of the cross stitch and, if desired, add the small beads, using one strand of matching stranded cotton (floss) and a half cross stitch.
4 When the stitching is complete, check for missed stitches and refer to page 123 for making-up instructions.
5 You will see we have made this pillow more glamorous by adding ribbons and a beaded twisted cord (thread some beads on one of the threads to be twisted and spread them along the length before you twist, see page 122).

(Opposite) The Christmas Rose Cross Stitch Picture and the Daisy Shaker Box

WOOLWORK CUSHIONS

The five cushions on the sofa opposite are made by completing a woolwork panel and then setting it into a cushion cover according to the instructions given on page 123. Although the finished panels are only 6 inches (15cm) square, they make an attractive full-sized cushion cover when inset; the green fabric matches the long-legged cross stitch edge, and the pale gold background of the embroidered panels is picked out by the cushion piping. It is always worth taking trouble to find fabrics that match your embroidery well.

General instructions for all the woolworks are given on page 70. The Strawberry is pictured on page 69, shown partly worked on page 71, and the line drawing and stitching instructions are on page 73. The Christmas Rose is pictured on page 80, and the line drawing and stitching instructions are on page 79. The Daisy is pictured on page 81, and the line drawing and stitching instructions are on page 83 The Blackberry is pictured on page 88, and the line drawing and stitching instructions are on page 86. The Violet is pictured on page 89, and the line drawing and stitching instructions are on page 91.

CHRISTMAS ROSE
WOOLWORK

Refer to page 70 for general woolwork instructions before following the specific instructions given below.

1 Begin the stitching with the leaves, using dark and medium green. Work the outer medium green layer of long-and-short stitches first. Work into every canvas hole around the edges,

The five woolwork panels set in to cushion covers

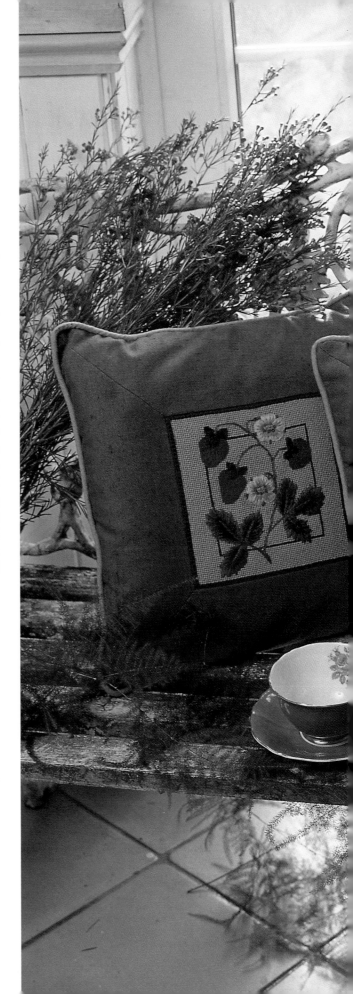

CHRISTMAS ROSE

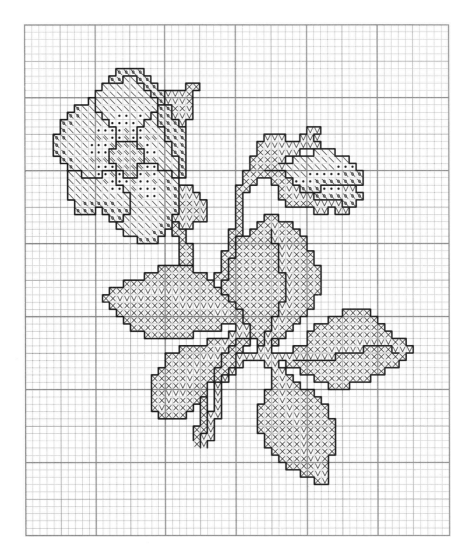

CHRISTMAS ROSE (CROSS STITCH)

		DMC	ANCHOR	APPLETON
	dark pink	223	0895	221
	old gold	729	0890	693
	medium green	3347	0266	244
	flesh pink	225	0892	877
	cream	712	0926	992
	dark green	937	0268	245

Optional outline

	DMC	ANCHOR	APPLETON
Flowers	223	0895	221
Leaves	937	0268	245

but change the direction of the stitches as you work your way around the leaf by overlapping in the centre. You will find it easier to come up through the canvas on the outside and down towards the centre of the leaf. A long stitch should alternate with a short one but do not be too rigid about this. As you work, be aware of the direction of each thread that you lay on the canvas — each stitch should be almost like a brush stroke on a painting.

2 Stitch the next layer in the darker shade, working from the centre of the leaf outwards. To blend the colours, you should take care to split

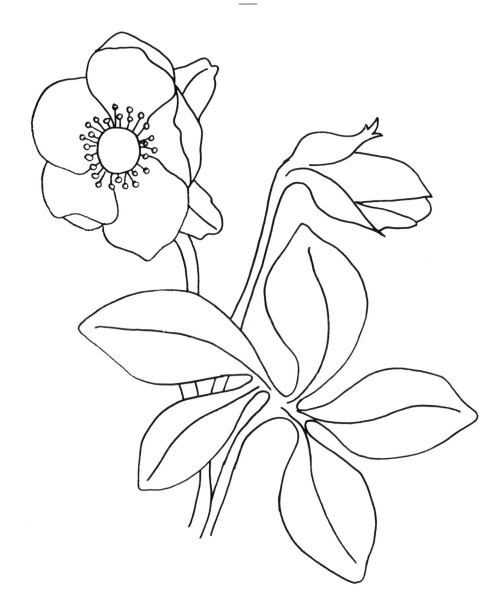

the threads of the last layer of stitching.

3 The turned-over sections of three of the petals are in pink satin stitch; work these first. Stitch the remainder of these petals in long-and-short stitch in pale pink and white. Work the other two petals in long-and-short stitch, shading from pink at the outer edge through pale pink to white in the centre of the flower.

4 Fill the centre of the flower with gold tent stitch, and work a ring of French knots around this tent stitch. Work a further row of knots on the petals, and give each one a short stitch to make a stalk.

CHRISTMAS ROSE (WOOLWORK)

	APPLETON	NUMBER OF SKEINS
dark green	245	1
mid-green	244	1
pale green	242	1
pink	221	1
very pale pink	877	1
white	992	1
very pale green	351	1
gold	693	1

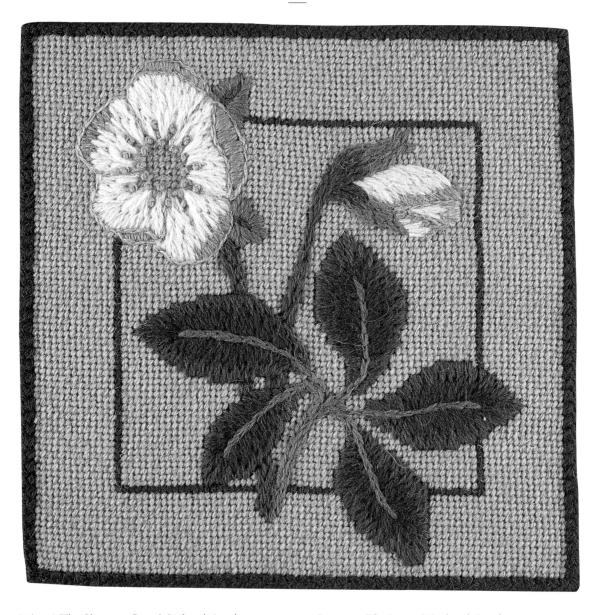

(Above) The Christmas Rose Woolwork (working instructions page 76, outline drawing page 79)

(Opposite) The Daisy Woolwork (working instructions page 81, outline drawing page 83)

5 Outline all petals in split back stitch, using one strand only of very pale green. The two little side leaves to the flower are in satin stitch and are worked in light green.

6 Embroider the entire section of the bud in long-and-short stitch in very pale green and pale pink, and the outer petals in pink and pale pink. These petals are outlined in split back stitch, using one strand of very pale green.

7 Embroider the outer leaves of the bud in long-and-short stitch, shading from light at the ends to mid-green, which then carries on down the stem in split back stitch, with two or three rows running next to each other. Work the other flower stem in the same way.

8 Stitch the stem and veins of the leaf in split stitch, using light green, and the veins on the little side leaves to the flower in mid-green.

DAISY WOOLWORK

Refer to page 70 for general woolwork instructions before following the specific instructions given below.

1 Begin the stitching with the leaves. They are all worked in medium and pale green, using long-and-short stitch. Start at the outer edge of each leaf, using mid-green and alternating a long stitch with a short stitch; work into every canvas hole along the curved end of the leaf. Work this first row of stitches with the needle coming up on the outer edge and going down towards the centre of the leaves, overlapping when required to maintain the correct direction of the stitch. Successive rows of stitches are worked with the needle coming up towards the centre of the leaf and going down through the stitches already in place. Take care to split the threads of the

DAISY

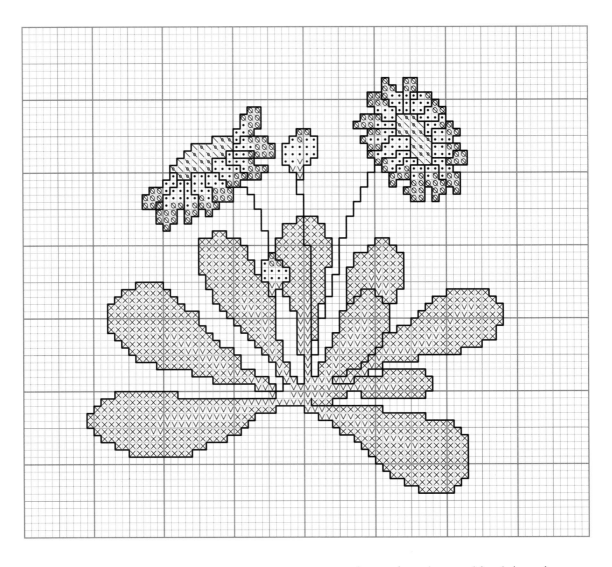

DAISY (CROSS STITCH)

		DMC	ANCHOR	APPLETON
⊠	old gold	729	0890	695
◩	yellow	743	0305	472
⊘	pink	760	09	221
▫	cream	712	0926	882
ⱽ	medium green	3347	0266	244
⊠	dark green	937	0268	245

Optional outline

		DMC	ANCHOR	APPLETON
Flowers		937	0268	245
Leaves		937	0268	245

previous layer of stitching to blend the colours, especially when you switch to pale green at the centre of each leaf. Take care also with the direction of the stitches; every stitch on a leaf should seem to radiate out of the centre of the plant, where all the leaves meet.

2 Work the two flower buds in long-and-short stitch, starting with the pink at the top and then working a layer of white, followed by a layer of pale green.

3 Stitch the flower petals in long-and-short stitch, working first in pink around the outer edge and then in cream. As you embroider these

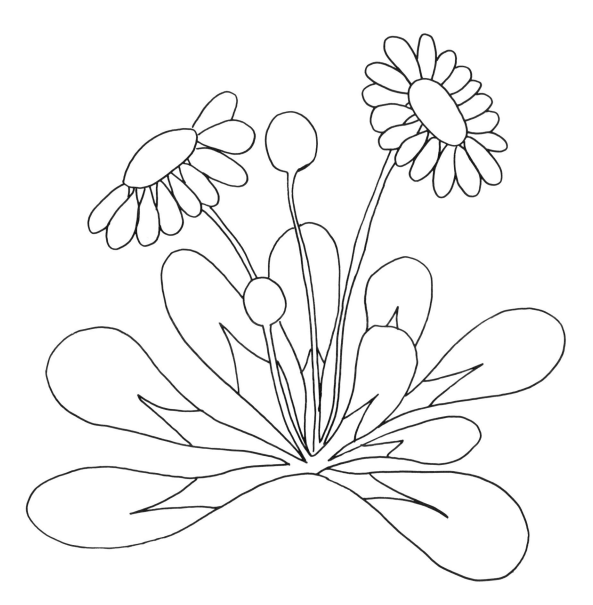

petals, don't worry that they seem to merge with each other, you will define them later with split back stitch.

4 Once you have worked all the petals, fill the centre with tent stitch in gold and then cover this tent stitch with tightly-packed French knots. Working the tent stitch first makes the French knots easier to stitch and also gives a raised appearance to the centres.

5 Using one strand of pink yarn, work split back stitch carefully around each petal.

6 Using one strand of mid-green yarn, work a row of French knots between the petals and the gold centre, placing one knot at each point where one petal adjoins the next.

7 Work all the stems in pale green, using split back stitch. If lines have been obscured by your stitching, refer to the picture on page 81.

DAISY (WOOLWORK)

	APPLETON	NUMBER OF SKEINS
dark green	245	1
medium green	244	1
pale green	242	1
pink	221	1
cream	882	1
gold	695	1

BLACKBERRY CROSS STITCH PICTURE

This pretty project is worked in cross stitch and then embellished with French knots and small seed pearls. In addition to stranded cotton (floss) we used a little brightly coloured rayon thread to add a touch of sparkle to the flowers and blackberries.

DESIGN SIZE: 4 x 4 inches (10 x 10cm)
STITCH COUNT: 58 x 54

8 x 8 inches (20 x 20cm) of 28-count in linen, in rose pink
Stranded cottons (floss) as listed on page 87
Marlitt rayon thread in Pink 879 and Lilac 857 (optional)
Size 26 tapestry needle
Sharps or beading needle
Eight seed pearls

1 Work a narrow hem around the edge of the linen to prevent fraying. Fold the fabric in four, press lightly and mark the folds with lines of tacking (basting) stitches.
2 Following the chart on page 87, and starting from the centre, use two strands of stranded cotton (floss) for the cross stitch and one strand for the back stitch outline. Always add the outline after working the cross stitch, using the shades suggested on the chart.
3 When the cross stitch is complete, work random French knots (see pages 111–12) on top of the cross stitch, using a mixture of stranded cotton (floss) and rayon thread.
4 Add seed pearls to the flowers, using a sharps needle and half cross stitches.
5 Check for missed stitches, then stretch and mount as preferred (see page 113).

84

VIOLET CROSS STITCH CUPBOARD

The striking design has been stitched on coarse linen and fitted into a purchased wooden cupboard. If you are planning to use a particular frame, box or card, always check the stitch and thread count before you start. The framed area in our cupboard measured 6 inches (15cm) square and the fabric was cut to allow for turnings.

DESIGN SIZE: 3 x 4 inches (7.5 x 10cm)
STITCH COUNT: 43 x 56

8 x 8 inches (20 x 20cm) of unbleached 20-count linen
Stranded cottons (floss) as listed on page 90
Purchased wooden cupboard or box

1 Work a narrow hem around the edge of the linen to prevent fraying. Fold the fabric in four, press lightly and mark the folds with lines of tacking (basting) stitches.
2 Following the chart on page 90 and starting from the centre, use three strands of stranded cotton (floss) for the cross stitch and two strands for the back stitch outline. Always add the outline after working the cross stitch, using the shades suggested on the chart.
3 Check for missed stitches, then stitch and mount as preferred (see page 113). Fit the mounted embroidery into the cupboard, following the manufacturer's instructions.

The Blackberry Cross Stitch Picture and the Violet Cross Stitch Cupboard

BLACKBERRY WOOLWORK

Refer to page 70 for general woolwork instructions before following the specific instructions given below.

1 Begin the stitching with the leaves, working them in satin stitch in the paler green. As you work the satin stitch between the lines of the veins on the leaves, you will find sometimes, especially towards the tip of a leaf, you need to overlap into the same hole to keep the stitches running in the correct direction.

BLACKBERRY (WOOLWORK)

	APPLETON	NUMBER OF SKEINS
dark green	245	2
medium green	244	2
cream	882	1
dark wine	935	1
dark red	227	1
pale mauve	601	1
brown	305	1

BLACKBERRY

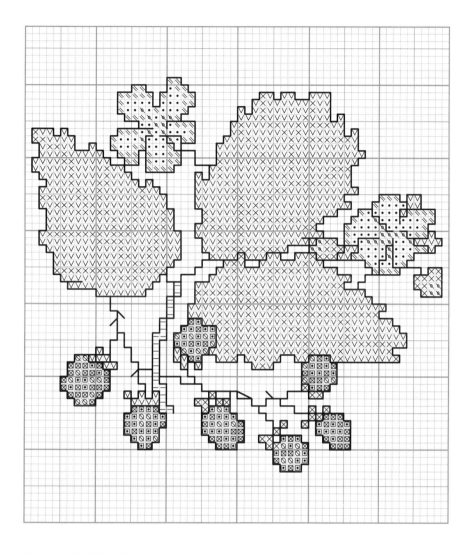

BLACKBERRY (CROSS STITCH)

		DMC	ANCHOR	APPLETON
☑	light green	3347	0266	242
⊟	brown	801	0358	305
▨	pale pink	818	048	751
⊡	cream	ecru	0926	992
▨	rosy pink	224	0893	753
⊠	dark green	937	0268	245
⊚	lilac	553	098	453
▣	dark purple	327	059	455
⊠	dark blue	939	0153	106

Optional outline

	DMC	ANCHOR	APPLETON
Leaves	937	0268	245
Flowers	327	0100	455
Blackberry	939	0152	106
Stems	801	0358	305

2 Use split back stitch in brown for the stems and main veins of the leaves, always stitching in the direction in which the stems would grow.

3 Working in tent stitch and dark wine, fill the shape of each blackberry, then cover the black-berries with very tightly-packed French knots. Working the tent stitch first makes the French knots easier to stitch and also gives a raised appearance to the berries. For these knots, use three strands of dark wine for the three berries to the right and at the end of the stem and for the remaining four to the left, which are not yet quite ripe, mix one strand of dark red with two strands of dark wine.

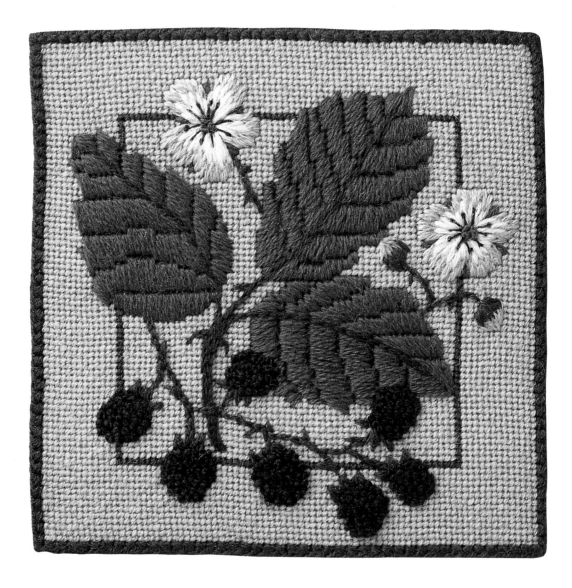

4 Work the blackberry stems in dark green split back stitch. Work the thorns as you go along the stems and stitch three sepals on each berry; each thorn is made with one straight stitch and the sepals are two or three straight stitches.

5 Work the flowers in long-and-short stitch, beginning with a row of pale lilac around the outer edge of the petals. Start at the outer edge of each petal, alternating a long stitch with a short stitch and stitching into every canvas hole along the curved edge. Work this first row of stitches with the needle coming up on the outer edge and going down towards the flower's centre, overlapping

stitches when required to maintain the correct direction of the stitch. Make a second row of stitches in cream and take care with the direction so that each seems to radiate out of the centre.

6 Using the paler green, work a small sepal between each of the petals and three French knots in the centre of each flower. Using one strand of dark wine, make several straight stitches radiating from the centre of each of the flowers and place a French knot at the end.

7 Make the two small buds in long-and-short stitch in pale lilac and dark green, and stitch the stems and thorns as for the blackberry stem.

VIOLET WOOLWORK

Refer to page 70 for general woolwork instructions before following the specific instructions given below.

1 Begin the stitching with the leaves, working the front right and the back left in pale and medium green and the others in medium and dark green. Work the outer and darker layer of stitches first. Stitch into every canvas hole around the edges, but change the direction of the stitches as you work your way around the leaf by overlapping in the centre. You will find it easier to come up through the canvas on the outside and down

(Opposite) The Blackberry Woolwork (working instructions and outline drawing page 86) and (above) The Violet Woolwork (working instructions above and outline drawing page 91)

VIOLET

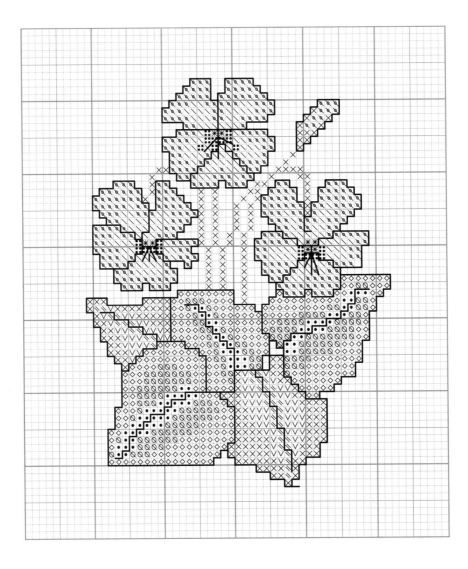

VIOLET (CROSS STITCH)

		DMC	ANCHOR	APPLETON
⊠	dark blue	939	0152	106
✳	corn yellow	676	0891	693
⊞	cream	712	0926	882
◩	purple	208	0111	452
∨	mint green	368	0214	401
✕	dark green	367	0216	294
◉	dark olive	937	0268	245
◎	light olive	470	0266	242
◇	pale mint	369	0213	874
⊡	pale lime	472	0278	241

Optional outline

	DMC	ANCHOR	APPLETON
Flowers	939	0152	106
Leaves	937	0268	245

towards the leaf's centre. A long stitch should alternate with a short one, but not not be too rigid about this. As you work, be aware of the direction of each thread that you lay on the canvas; each stitch should be almost like a brush stroke on a painting. The next layer is stitched in the paler shade and is worked from the centre of the leaf outwards. To blend the colours, split the threads of the previous layer of stitching.

2 The flowers are worked in exactly the same way; the top two petals of each flower are shaded in dark and light violet, and the three lower petals shade from dark violet through to cream in

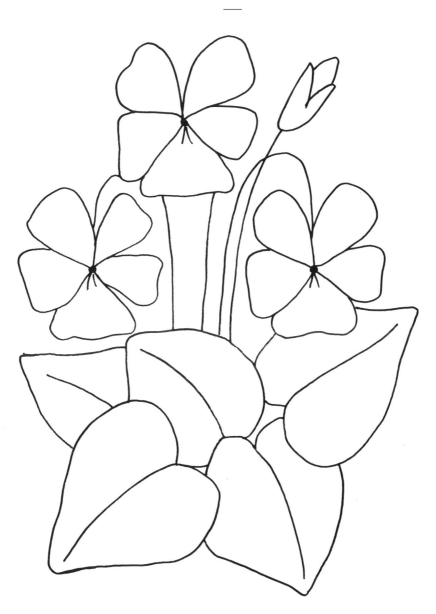

the centre. Outline the petals in split back stitch, using one strand only of dark violet, and add two or three stitches over the cream shading on the bottom petal. Using one strand of gold, work five French knots in the centre of each flower.

3 Stitch the little bud in dark violet and medium green yarn.

4 Work the stems of the flowers in split back stitch in medium green. The veins on the leaves are also in split back stitch, but in dark green.

VIOLET (WOOLWORK)

	APPLETON	NUMBER OF SKEINS
dark green	245	2
medium green	244	2
pale green	242	1
dark purple	607	1
light purple	604	1
cream	882	1
gold	473	1

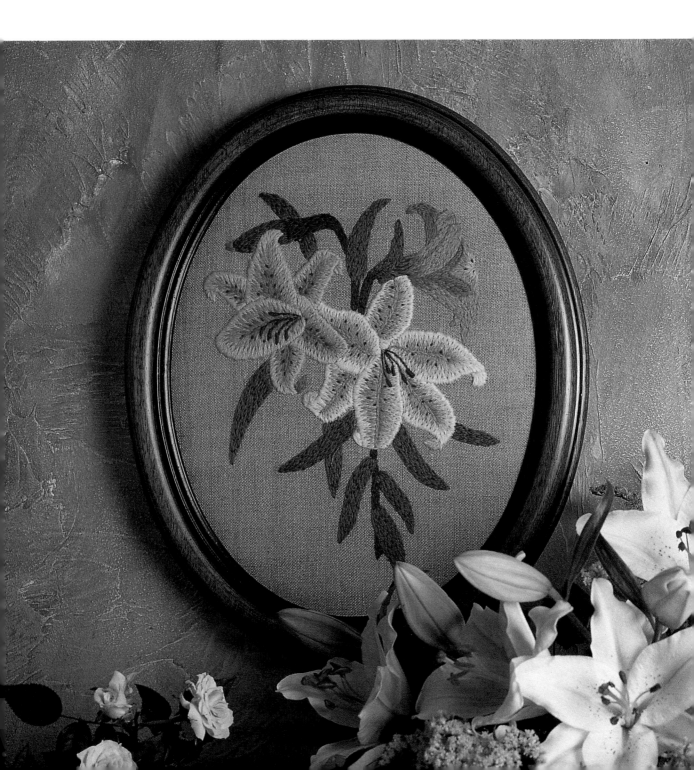

CHAPTER FOUR

Lilies

We felt a collection of flower designs was not complete without the natural grace of the Lily and that it was time that we became a little more sophisticated. All the projects in this short chapter are based on the same design; we have simply stitched it in different ways or only used parts of it. Varied effects can be obtained from the different techniques used.

Below, you can see the fine cross stitch version on the right, which has been stitched straight from the chart, contrasted with the much more robust crewelwork flowers on the left. We used the same design, but stitched the crewelwork flowers from the outline drawing, substituting four shades of golden yellow for the four shades of pink on the charted version.

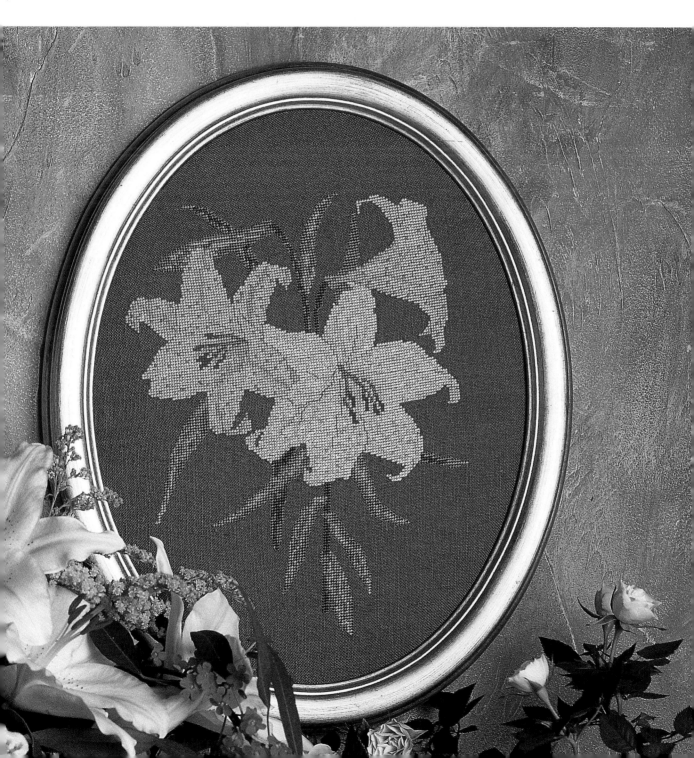

CROSS STITCH LILY PICTURE

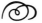

This elegant lily design has been stitched, as described here, on dark green linen and framed in a gold coloured frame (see page 92) and has also been worked on a grey fabric and trimmed with lace (see pages 98–9), for a very different effect.

DESIGN SIZE: 8¾ x 11½ inches (22 x 29cm)
STITCH COUNT: 125 x 163

13 x 15 inches (33 x 38cm) of 28-count linen
in dark green
Stranded cottons (floss) listed on page 97
Size 26 tapestry needle

1 Work a narrow hem around the edge of the linen to prevent fraying. Fold the fabric in four, press lightly and mark the folds with lines of tacking (basting) stitches.
2 Following the chart on pages 96–7 and starting at the centre, stitch the lilies, using two strands of stranded cotton (floss) for the cross stitch and one strand for the back stitch outline.
3 When the cross stitch is complete, check for missed stitches and stretch and mount as preferred (see page 113).

CREWELWORK LILY PICTURE

Here we have used the tracing from the original cross stitch chart and simply re-coloured it. The design was embroidered with quite large stitches, with two strands of crewel wool, allowing the shading to follow the simple lines of the flower.

15 x 20 inches (38 x 50cm) of natural linen (the fabric
used here is a 30-count evenweave linen)
One skein each of the Appleton crewel wools listed
Size 5 crewel needle
12in (15cm) embroidery hoop or frame
Water-soluble pen
Black felt-tip pen
Sheet of tracing paper

**Two strands of crewel wool are used throughout unless
otherwise stated**
**Stitches used: split back stitch, long-and-short stitch,
French knots and bullion knots (see pages 119–21)**

1 Trace the outline on to your fabric (see page 12) and mount into your hoop or frame.
2 Refer to the picture on pages 92–3 while you are stitching. The flower on the left is worked using dark, medium, and pale yellow. Underline all the petals in split back stitch and work one row of long-and-short stitch in each shade of yellow, starting with the pale shade at the outer edge and shading to dark in the middle.
3 Make the stems of the stamens in dark green split back stitch, using one strand of crewel wool; put a deep red bullion knot at the end.
4 Each petal has several deep red French knots scattered over the area towards the centre; make these with one strand of crewel wool.
5 Repeat the above instructions for the central lily, but use medium, pale and very pale yellow.
6 Stitch the flower on the right with dark and medium yellow only.
7 Give the unopened bud a dark yellow tip and stitch the rest of the bud and all the leaves in pale green long-and-short stitch, working from the tips of the leaves down to the dark green stems.
8 Rinse the finished piece gently to remove the water-soluble pen outlines, and refer to page 121 for stretching and mounting instructions.

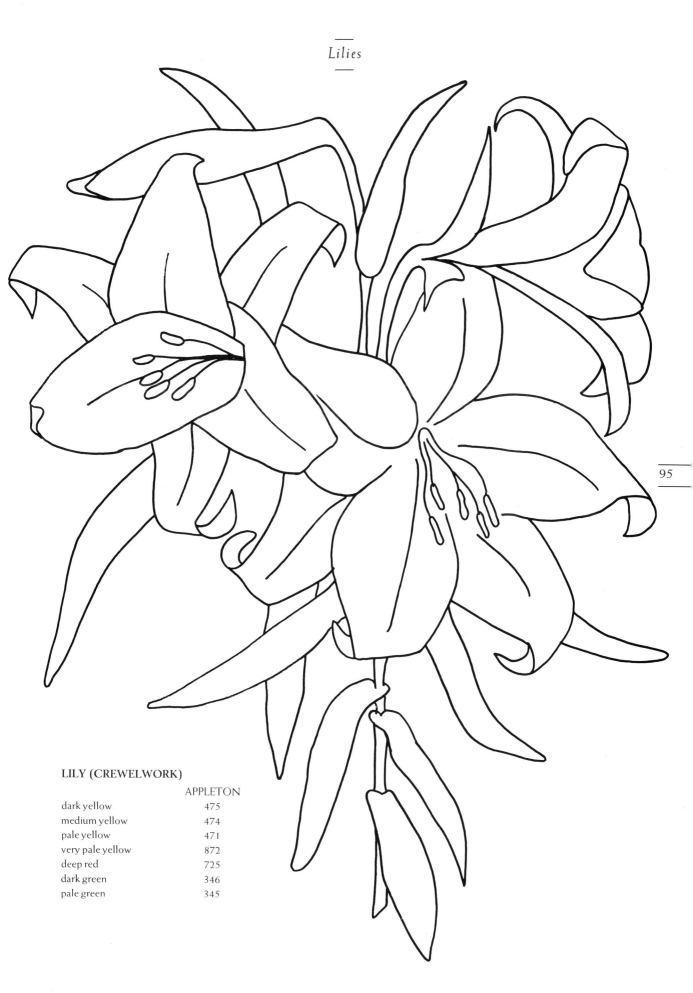

LILY (CREWELWORK)

	APPLETON
dark yellow	475
medium yellow	474
pale yellow	471
very pale yellow	872
deep red	725
dark green	346
pale green	345

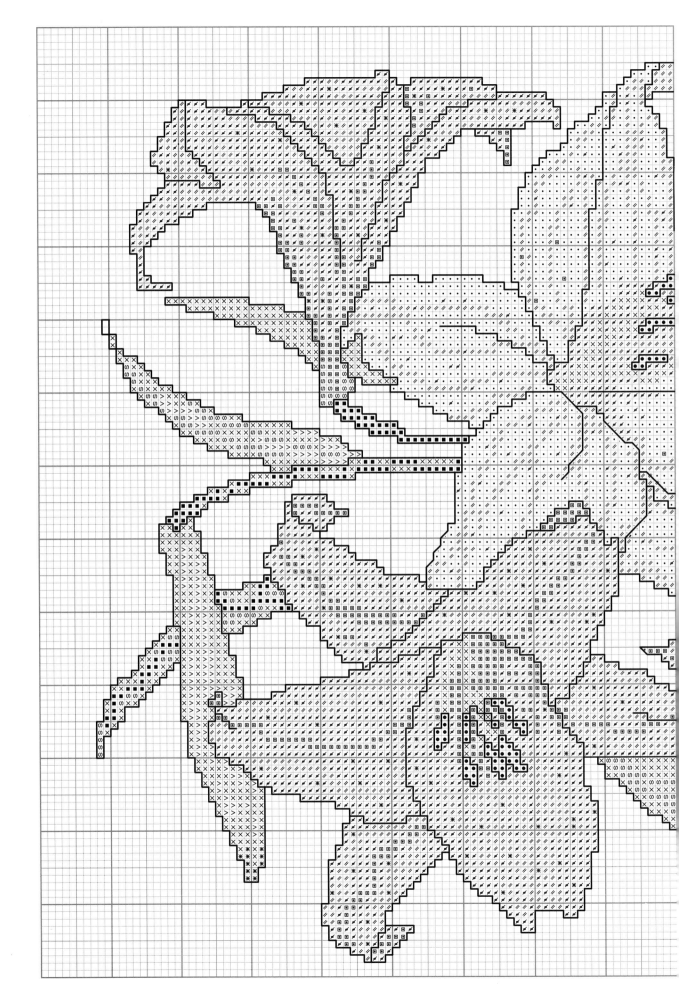

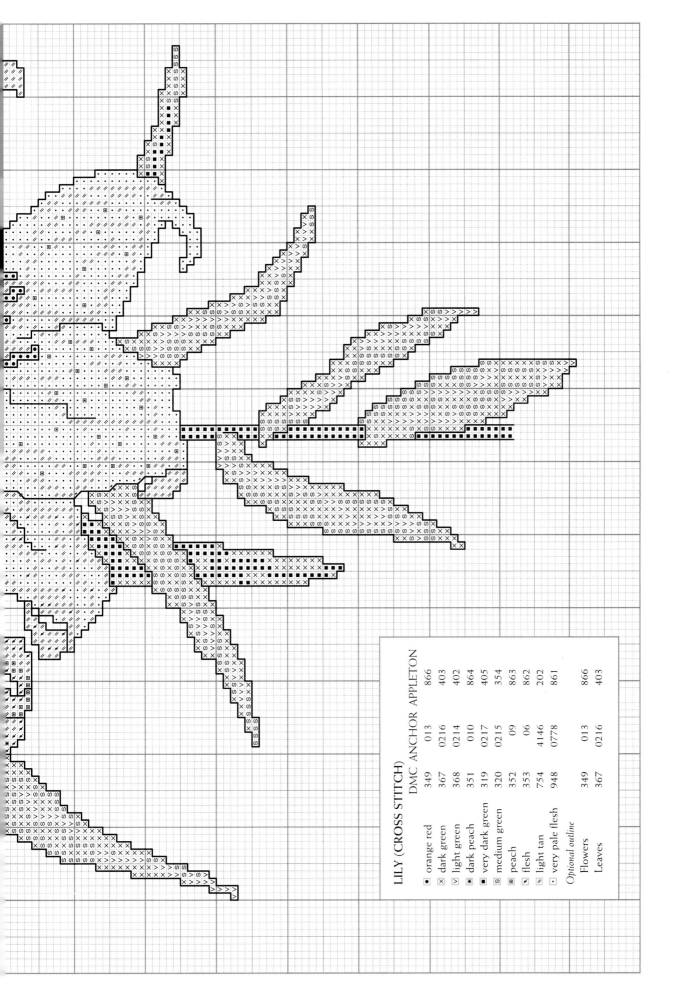

LILY (CROSS STITCH)

		DMC	ANCHOR	APPLETON
•	orange red	349	013	866
⊠	dark green	367	0216	403
▷	light green	368	0214	402
✱	dark peach	351	010	864
■	very dark green	319	0217	405
s	medium green	320	0215	354
⊡	peach	352	09	863
✎	flesh	353	06	862
⊘	light tan	754	4146	202
·	very pale flesh	948	0778	861

Optional outline

Flowers		349	013	866
Leaves		367	0216	403

CROSS STITCH NIGHTDRESS CASE

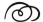

The nightdress case opposite, which measures 12 x 10 inches (30 x 25cm), has been stitched from the chart on pages 96–7 except that the stem and three lower leaves have been omitted.

DESIGN SIZE: 8¾ x 9¼ inches (21 x 20cm)
STITCH COUNT: 125 x 130

16 x 14 inches (40 x 35cm) of 28-count linen in dark grey
Two pieces of satin fabric, for backing, one 13 x 31 inches (33 x 78.5cm) and one 13 x 21 inches (33 x 53cm)
13 x 31 inches (33 x 78.5cm) of polyester wadding/batting
Stranded cottons (floss) listed on page 97

Size 26 tapestry needle
59 inches (150cm) of antique white lace, 3 inches (7.5cm) wide
2 yards (1.8m) of satin bias binding

1 Work a narrow hem around the edge of the fabric to prevent fraying. Fold the fabric in four, press lightly and mark the folds with lines of tacking (basting) stitches.
2 Following the chart on pages 96–7 and starting at the centre, stitch the lilies, using two strands of stranded cotton (floss) for the cross stitch and one strand for the back stitch outline.
3 When the cross stitch is complete, check for missed stitches and make up as described on page 125.

CANVASWORK BOX LID

The box lid has been stitched from the chart on pages 96–7. Only the lily flower on the left of the chart has been used, and the stem and leaves of the central lily have been moved to balance the design. We have used stranded cotton (floss) to stitch the design and wool for the background. This makes the lily stand out against the wool background.

DESIGN SIZE: 4½ x 9 inches (11.5 x 23cm), but the design can be easily adapted

14 x 9 inches (35.5 x 23cm) of 18-count canvas
Stranded cottons (floss) listed on page 97
One hank Appleton crewel wool 931
Size 22 tapestry needle
Purchased wooden box
Masking tape

Two strands of crewel wool or six strands of stranded cotton (floss) are used
Stitches used: tent stitch and diagonal tent stitch (see page 116)

1 Bind the canvas edges with masking tape.
2 Following the chart on pages 96–7, using tent stitch and all six strands of stranded cotton (floss), stitch the lily flower on the left and add the stem and leaves of the central lily.
3 You will need to estimate the central position for the design on your canvas. Draw pencil lines on the canvas to surround the single lily in the centre. The lines should measure 4½ x 9 inches (11.5 x 23cm) to fit the box seen here, but you may have to adjust these dimensions if your box is different.
4 Complete the background to fill the marked-out area, using diagonal tent stitch and two strands of crewel wool.
5 Refer to page 117 for stretching instructions and mount the embroidery into the lid according to the manufacturer's instructions.

(Opposite) The Cross Stitch Nightdress Case and the Lily Canvaswork Box Lid

Silk miniatures

The designs in this final chapter are not strictly crewelwork, but are developed from embroidery designs that are essentially very akin to crewelwork. Indeed the stitches used are exactly the same, only the thread and fabric differ. The five small designs were inspired by the myriad of plants and creatures in the backgrounds of Tudor embroideries. This work often goes unnoticed because it is not part of the main design and is usually only there to cover flaws in the fabric. The silk miniatures are worked in stranded cotton on silk dupion. Do not be frightened by the silk: it is not difficult to work on and the texture contrasts so well with the delicate embroideries.

USING THE DESIGNS

The Silk Wedding Purse and the Bell Pull on this page are made using designs shown on the following pages. The pretty silver bag top and the brass bell pull end were both antique shop finds, which makes it impossible for you to buy identical ones. How much cream silk dupion you need and how you place the designs and make up these pieces will depend on the type of bag fastening or bell pull end that you are able to obtain.

(Left) The Silk Bell Pull and (opposite) the Silk Wedding Purse

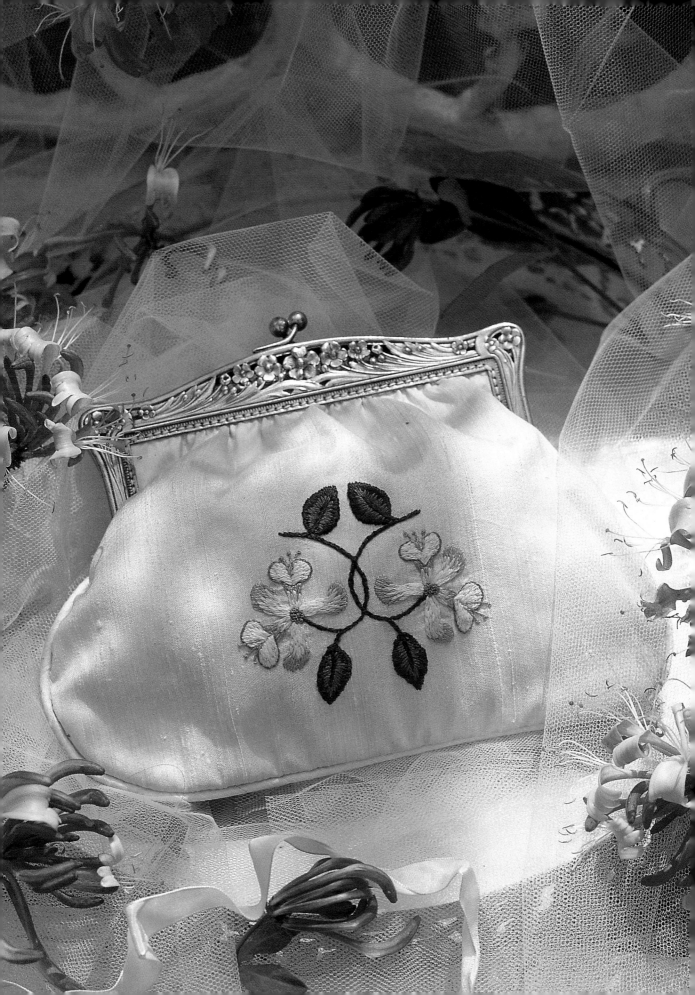

SILK WEDDING PURSE

The entwined honeysuckle motif on the silk wedding purse has been adapted from the design opposite by repeating the flower and entwining

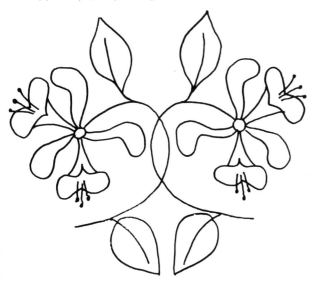

the two to make a mirror-imaged pair, and omitting the caterpillar. If you purchase a modern bag top it will come with instructions and a pattern for the fabric pieces. Trace off the outline left and place it carefully to suit your bag. Follow the tracing and stitching instructions opposite for the honeysuckle and then make up the bag following the manufacturer's pattern and instructions. If you find an old bag top, we suggest that you make your own pattern from a piece of scrap fabric to check that you have the correct shape before you risk your embroidered silk! We have added a silk piping around the bottom edge and hand-stitched the bag to the silver top to make it a little more special. If the bag is to be a gift, you could also embroider the initials of the bride and groom on the reverse side.

SILK BELL PULL

The Bell Pull uses all the miniature flowers and four of the insects that accompany them. Trace all the outlines on to a sheet of tracing paper and then cut around each design, leaving a margin. Now you can play around with the designs until you come to an arrangement that pleases you and suits your bell pull end. Once you have done this, you can glue all the separate design elements to another sheet of tracing paper, then trace the design on to your silk. Follow the stitching instructions on the following pages for each separate flower. We added a contrasting silk piping to edge the bell pull, choosing one that toned in with the stranded cottons used for the embroidery, and we shaped the bottom to fit the small brass end. As for the wedding purse, you should follow the manufacturer's instruc-

tions if you have purchased modern ends; if you find an antique set, use some scrap fabric to make your own pattern. You will find that the silk looks better when the natural slubs in the weave run up and down the length of the bell pull rather than across it.

SILK MINIATURES
The requirements and stitches used for each of the pictures that follow are exactly the same; they are listed only once at the beginning of the Honeysuckle instructions. You will need to refer back to them to complete the pictures. There is a list of stranded cotton (floss) colours with each set of instructions. To stitch the complete set of miniatures you need only purchase one skein where a colour appears in more than one list.

HONEYSUCKLE

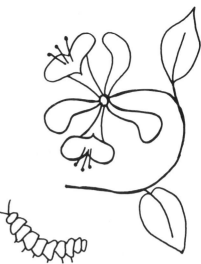

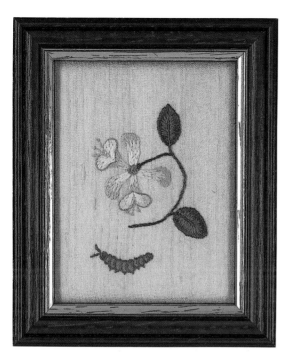

8 x 8 inches (20 x 20cm) of cream silk dupion
Stranded cottons (floss) listed for each design
Size 7 crewel needle
6 inch (15cm) embroidery hoop or small frame
Water-soluble pen
Black felt-tip pen
Sheet of tracing paper
Purchased frame at least 3 ½ x 4 ½ inches
(9 x 11.5cm)

**Three strands of stranded cotton are used unless
otherwise stated
Stitches used: split back stitch, long-and-short stitch,
French knots, stem stitch and satin stitch (see pages
119–21)**

HONEYSUCKLE

	DMC	ANCHOR
pale coral	3774	0778
mid-coral	3773	0882
dark coral	3772	0914
bright gold	783	0307
dark green	936	0846
pale green	732	0281
dull gold	680	0901
brown	839	0360
ecru	ecru	0387

1 Unless you are using a transfer (see page 127), trace the outline and draw the design on the silk (see instructions on page 12).

2 Using dark green, outline each leaf in split back stitch and then work long-and-short stitch over this back stitch edge. This gives a raised effect to the edge of the leaf and also makes it easy to make a nice smooth line of stitches. Fill the centre of each leaf with a layer of pale green long-and-short stitch. The stems and leaf veins are dark green stem stitch.

3 Embroider the three unopened petals in long-and-short stitch, shading from mid-coral on the outer end through pale coral to ecru in the centre.

4 Work the shanks of the two open petals in mid-coral, with pale coral towards the centre of the flower. The open ends are pale coral around the edges and ecru towards the centres. The edge of these open petals is outlined in dark coral split back stitch, using one strand.

5 Stitch stamens in one strand of bright gold stem stitch, with a French knot at the end.

6 Make the centre of the flower with French knots in dark coral, packing these tightly together.

7 Using one strand of brown, embroider the entire outline of the caterpillar in split back stitch, work the feelers in stem stitch and make one tiny stitch for each little leg. Fill in the head with brown satin stitch and all the segments with dull gold satin stitch.

8 When the stitching is complete, rinse gently to remove the water-soluble pen and refer to page 121 for stretching and mounting instructions.

HEARTSEASE

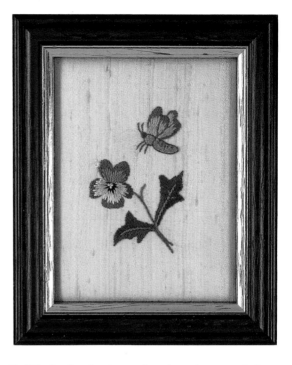

1 Unless you are using a transfer (see page 127), trace the outline and draw the design on the silk (see instructions for the Poppy crewelwork design on page 12).

2 Using dark green, outline each leaf in split back stitch and then work long-and-short stitch over this back stitch edge. This gives a raised effect to the edge of the leaf and also makes it easy to make a nice smooth line of stitches. Fill the centre of each leaf with dark green long-and-short stitch. The stems and leaf veins are pale green stem stitch. Make lower stem with a double row of stem stitch, leading into the veins of the leaves.

3 Work long-and-short stitch in dark mauve around the outer edges of all the petals.

4 Complete the top two in pale mauve long-and-short stitch. For bottom three petals, use three more colours – pale gold, dark gold and dark brown.

5 Using one strand of pale gold, work three French knots in the centre of the pansy.

6 Work long-and-short stitch in red brown around the outer edges of the bug's wings, and complete the wings in coral pink. Outline them in split stitch in red brown.

7 Work the body and tail in long-and-short stitch in dull gold. Using one strand of brown, work the head in satin stitch and outline the body, tail and head in split back stitch and the lines on the tail. Work the legs and feelers in stem stitch in one strand of brown.

8 When the stitching is complete, rinse the finished piece gently to remove the water-soluble pen outlines and refer to page 121 for stretching and mounting instructions.

HEARTSEASE

	DMC	ANCHOR
dark mauve	3740	0872
pale mauve	3041	0871
dark gold	783	0307
pale gold	677	0300
dark green	936	0846
pale green	732	0281
dark brown	3371	0382
dull gold	680	0901
reddish brown	632	0936
coral pink	3773	0882
brown	839	0360

ROSE

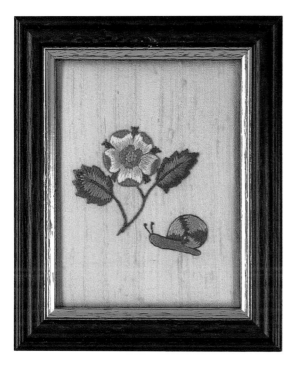

1 Unless you are using a transfer (see page 127), trace the outline and draw the design on the silk (see instructions for the Poppy crewelwork design on page 12).

2 Using dark green, outline each leaf in split back stitch and then work long-and-short stitch over this back stitch edge. This gives a raised effect to the edge of the leaf and also makes it easy to make a nice smooth line of stitches. Fill the centre of each leaf with a layer of pale green long-and-short stitch. The stems and leaf veins are dark green stem stitch.

3 Work the inner area of the large petals in long-and-short stitch, starting with pale pink at the outside and shading to mid-pink in the centre of the flower. Fill the turned over edges of the petals and the little inner petals in dark pink satin stitch. Using one strand of dark pink, outline all the petals in split back stitch.

4 Using dark green, make three or four stitches between each petal, then add tiny stitches to make the thorn-like ends.

5 Make a tightly packed cluster of French knots in gold in the centre of the rose.

6 To work the snail, begin at the wide end of the shell with reddish brown long-and-short stitch. Be careful to make all your stitches follow the direction of the twist of the shell, changing and alternating with coral pink. Work the body in long-and-short stitch in gold.

7 Outline the shell and the body in brown split back stitch, using only one strand. Work the feelers, also using one strand of brown, in stem stitch, and add a French knot at the end of each.

8 When the stitching is complete, rinse the finished piece gently to remove the water-soluble pen outlines and refer to page 121 for stretching and mounting instructions.

ROSE

	DMC	ANCHOR
pale pink	225	0892
mid-pink	224	0893
dark pink	223	0895
pale green	470	0266
dark green	937	0268
gold	783	0307
coral pink	3773	0882
reddish brown	632	936
brown	839	0360
dull gold	680	0901

CARNATION

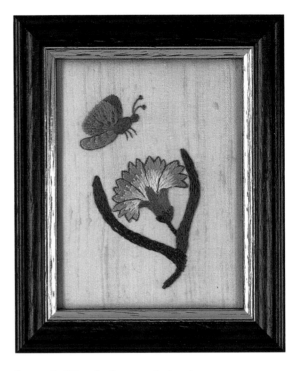

1 Unless you are using a transfer (see page 127), trace the outline and draw the design on the silk (see instructions for the Poppy crewelwork design on page 12).

2 Work a row of long-and-short stitch in dark salmon all around the flower edge. Shade in long-and-short stitch using mid-salmon and shading to pale salmon towards the centre.

3 Outline these petals in one strand of rust, using split back stitch. Use the photograph to help you with the placing of this outlining as you will have covered the lines on the fabric; there are four points on the outer petals and three on the middle three.

4 Begin the calyx with the three points at the top, using pale green long-and-short stitch. Work dark green cup at the bottom of the carnation in long-and-short stitch, taking care that all your stitches fan out from the bottom.

5 Work the long leaves in long-and-short stitch in dark green, using long flowing stitches and taking care with the direction of the stitches. Make two rows of dark green stem stitch for the upper stem and three rows for the lower one.

6 Work the head of the butterfly in satin stitch and the body in long-and-short stitch in brown. The tail is gold long-and-short stitch. Outline the body, tail and head in split back stitch, using one strand of brown and also make the stripes on

the tail. The feelers and the legs are in stem stitch in one strand of brown, with a French knot at the end of each feeler.

7 Work the front wing in pale mauve long-and-short stitch, shading to pink towards the body. Work the back wing in long-and-short stitch in dark mauve, and add some dark mauve French knots to the pink area of the front wing.

8 When the stitching is complete, rinse the finished piece gently to remove the water-soluble pen outlines and refer to page 121 for stretching and mounting instructions.

CARNATION

	DMC	ANCHOR
dark salmon	3778	9575
mid-salmon	3779	0868
pale salmon	3774	0778
rust	3777	020
dark green	936	0846
pale green	732	0281
dark mauve	3740	0872
pale mauve	3041	0871
pink	223	0895
dull gold	680	0901
reddish brown	632	936

LILY

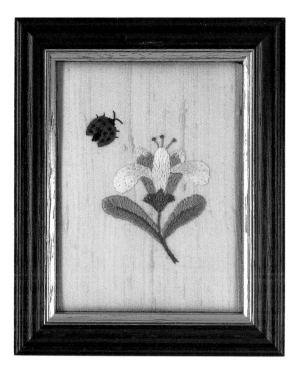

1 Unless you are using a transfer (see page 127), trace the outline and draw the design on the silk (see instructions for the Poppy crewelwork design on page 12).

2 Using pale green, outline each leaf in split back stitch and then work satin stitch over this back stitch edge. This gives a raised effect to the edge of the leaf and also makes it easy to make a nice smooth line of stitches. Work from the outside edge to the centre of the leaf, taking care with the direction of your stitches, particularly at the tip of the leaf. The stems and leaf veins are dark green stem stitch.

3 Work all the petals in long-and-short stitch. The turned-over sections of the side petals and the centre petal are worked in ecru at the outer edges and pale gold to the centre of the flower. The bottom of the side petals are in dark gold. Stitch the tips of the two inner side petals in pale gold shading to dark gold towards the centre of the flower. The stamens are worked in one strand of dark gold stem stitch. Put a French knot in red brown at the end of each.

4 The dark green cup at the bottom of the lily is in long- and short-stitch, take care that all your stitches fan out from the bottom.

5 Work the wings of the ladybird in long-and-short stitch in red and its body in long-and-short stitch in dark brown. Embroider the head in dark brown satin stitch. Make the spots with dark brown French knots (you will have covered the placing for these with red, use the photograph as a guide). The feelers are in one strand of dark brown stem stitch and the legs are tiny stitches, also in one strand of dark brown.

6 When the stitching is complete, rinse the finished piece gently to remove the water-soluble pen outlines and refer to page 121 for stretching and mounting instructions.

LILY

	DMC	ANCHOR
dark gold	680	0901
pale gold	677	0300
ecru	ecru	0387
reddish brown	632	0936
pale green	470	0266
dark green	937	0268
red	3777	020
dark brown	3371	0382

Materials and techniques

CROSS STITCH

FABRICS

All counted designs are made up of squares or parts of squares. The principle is that the picture, pattern or motif is transferred to the fabric by matching the weave of the fabric to the pattern or chart. The term 'counted' means that the design is transferred to the fabric by counting the squares on the chart and matching this on the fabric, so that each stitch will be put in the right place.

The fabrics used for counted cross stitch are all evenweave fabrics, which means that they have the same number of threads or blocks per inch (2.5cm) in both directions, the warp and weft being woven evenly so that when a stitch is formed it will appear on the fabric as a square or part of a square.

THREAD COUNTS

The thread count is the method by which manufacturers differentiate between the size of evenweave fabrics; the higher the number, the more fabric threads (in Aida, groups or blocks of threads) there are to the inch (2.5cm). A 14-count Aida therefore has 14 blocks each way per inch (2.5cm), whereas a 28-count linen has 28

threads and a 22-count Hardanger has 22 double threads per inch. In most cases, however, stitches are taken over two linen threads at a time, so an embroiderer will work 14 cross stitches each way over a 28-count linen (see also page 110).

AIDA

This excellent cotton fabric is woven for counted needlework and is ideal for the beginner. The threads are woven in blocks, or groups of threads, rather than singly. There are many projects that suit this fabric particularly well, as it forms a very pretty square stitch. Aida is available in 6, 8, 11, 14, 16 and 18 blocks to one inch (2.5cm). When stitching on Aida, one block on the fabric corresponds to one square on the chart. Working a cross stitch on Aida is exactly the same as on linen, except that instead of counting threads you count the single blocks.

LINEN AND COTTON

Lovely, if slightly more expensive, linen fabrics are also commonly used for counted cross stitch. Stitching on linen is no more complicated than stitching on Aida, but it requires a different

technique. Linen has irregularities in the fabric, which occur naturally and add to the charm of the finished piece, but to even out any discrepancies cross stitches are worked over two threads in each direction. Linen is generally available in white, antique white, cream, raw or natural shades and some shops stock specially-dyed coloured linens.

Cotton evenweaves include the Hardanger, with its 22 double threads per inch (2.5cm), used for fine work, and other fabrics, such as Linda (27-count) and Lugana (a 25-count cotton/rayon blend).

AFGHAN FABRICS

These soft fabrics, made from mixed fibres, are produced for shawl-like projects which can look wonderful thrown over the back of a chair. They are usually sold in squares or pattern repeats.

THREADS

A variety of threads are included in the book, but where stranded cotton (floss) has been used DMC keys are provided. Alternative Anchor numbers are quoted but an exact colour match is not possible. Stranded cotton (floss) is a six-ply mercerized cotton, which is usually divided before stitching. When necessary, the number of strands required will be indicated for the projects using stranded cotton (floss).

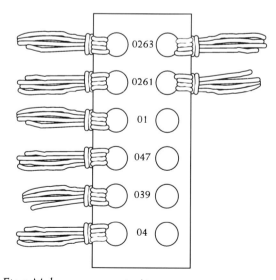

Fig 1 Make your own organizer

When you are stitching on linen and you are not sure of the number of strands needed for the cross stitch, the best way to find out is carefully to pull out a thread of the fabric and compare this with your chosen yarn; the thread on your needle should be roughly the same weight as that of the fabric.

When selecting threads, always have the fabric you are intending to use close at hand, because the colour of your background fabric will affect the choice of colours. When in a shop, check the colour of the thread in daylight, as electric light can 'kill' some shades. It is possible to buy 'daylight' bulbs to use in normal spotlights at home – a great help when shading a design in the evening.

It really does pay to start with good habits if possible, and have an organizer for your threads (Fig 1). There are many excellent systems on the market, but you can make your own cards, as shown in the diagram. The card from inside a packet of tights is excellent, but any stiff card will do. Punch holes down each side and take a skein of stranded cotton (floss). Cut the cotton into manageable lengths of about 20 inches (50cm) and thread them through the holes as shown. It is quite simple to remove one length of thread from the card without disturbing the rest. If you label the card with the manufacturer's name and shade number, all the threads will be labelled ready for the next project, when the one in hand has been completed.

NEEDLES

With all counted cross stitch you will need blunt tapestry needles of various sizes, depending which fabric you choose. The most commonly-used tapestry needles for cross stitch are sizes 24 and 26. Avoid leaving your needle in the fabric when it is put away, as it may leave a mark. The nickel plating on needles varies so much that some stitchers find their needles discolour and mark their hands and fabric; as a result, they treat themselves to gold-plated needles which may be used again and again.

If you are not sure which needle to choose, it is possible to check in the following way. Push

the needle through the fabric. It should pass through without enlarging the hole, but equally it should not fall through without any pressure.

When beads are suggested in a project, they may be attached using a fine sharp needle and a half cross stitch. Beading needles are available, but can be expensive if used rarely.

FRAMES AND HOOPS
This subject always raises questions and argument. It is not necessary to use a frame or hoop for cross stitch on linen or Aida. Having said

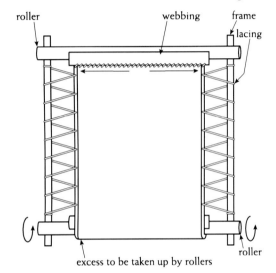

Fig 2 Rotating frame

Fig 3 Wooden hoop

that, it is a matter of personal choice and if you prefer to use one then please do so! The use of frames for canvaswork and crewel embroidery will be covered in the next section.

You may decide to use a rectangular frame; these come in a variety of shapes and sizes and can be hand-held or free-standing. The needlework is stitched to the webbing along the width of the frame and the excess material is taken up by rollers at the top and bottom (Fig 2). If you use a hoop (Fig 3), ensure that all the design is within the stitching area of the hoop and that you do not need to move it across worked areas, as this may drag and spoil your stitches.

SCISSORS
Keep a small, sharp pair of pointed scissors exclusively for your stitching. To avoid losing them, wear them around your neck on a ribbon.

THE CHARTS
The needlework charts in this book are illustrated in black and white, using a series of symbols to indicate the colour of the thread used. For cross stitching, each square, both occupied and unoccupied, represents two threads of linen or one block of Aida. Each occupied square equals one stitch.

CALCULATING DESIGN SIZE
All that determines the size of a cross stitch design is the number of stitches up and down. For those familiar with knitting, it is similar to the same number of stitches worked in 4-ply wool and in a chunky weight. To calculate the design size, look at the chart and count the maximum number of stitches in each direction. Divide this number by the number of stitches to be worked per inch (2.5cm) on the fabric of your choice, and this will determine the completed design size. The crucial factor with any counted needlework is the stitch count and the fabric count. Where appropriate, the stitch count is included in the projects so that you can simply adapt the projects to suit your fabric.

Before starting any of the counted projects in this book, it is vital to check the thread count of

Labels in Fig 2: roller, webbing, frame, lacing, excess to be taken up by rollers, roller

your chosen fabric and the stitch count of the chart you are intending to use and make sure that the design will fit. This is particularly important when the finished piece is intended to fit a special frame, trinket pot or card.

A CROSS STITCH

A cross stitch has two parts and can be worked in one of two ways: a complete stitch can be worked, or a number of half stitches may be stitched in one line, then completed on the return journey. The one essential rule is that all the top stitches should face the same direction.

Fig 4 Single cross stitch

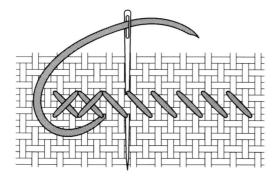

Fig 5 Part-completed stitches – completed on return journey

In the example shown here, the cross stitches are being worked on linen, over two threads of fabric, using two strands of stranded cotton (floss). Bring the needle up through the wrong side of the fabric, at the bottom left, cross two threads and reinsert the needle at the top right. Push the needle through, then bring it up at the

bottom right-hand corner, ready to complete the stitch in the top left-hand corner (Fig 4). To work the adjacent stitch, bring the needle up at the bottom right-hand corner of the first stitch (thus the stitches share points of entry and exit). To make part-completed stitches, work the first leg of the cross stitch as above, but instead of completing the stitch, work the next half stitch and continue to the end of the row. The crosses are completed on the return journey (Fig 5).

HOW TO START

Having learnt the basic cross stitch, you now need to know how to start stitching, using the knotless loop start (Fig 6). This method can be very useful with stranded cotton (floss), but it only works if you are intending to stitch with an

Fig 6 Knotless loop start

even number of threads. To stitch with two threads, cut the stranded cotton (floss) roughly twice the length you would normally need and carefully separate one strand. Double this thread and thread your needle with the two ends. Pierce your fabric from the wrong side where you intend to place your first stitch, leaving the looped end at the rear of the work. Return your needle to the wrong side after forming a half cross stitch, and pass the needle through the waiting loop. The stitch is anchored and you may begin to stitch. (For four-thread stitching, you will, of course, start with two long strands.) When working with an uneven number of threads, start by anchoring the threads at the back of the work under the first few stitches.

HOW TO FINISH

When a group of stitches or a length of thread is completed, finish off the end carefully before

starting a new colour. At the back of the work, pass the needle under stitches of the same or similar colour and snip off the loose end close to the stitching. Small loose ends have a nasty habit of pulling through to the right side!

WHERE TO START

It can be nerve-racking at the start, when you are faced with a plain unprinted piece of fabric, but it is really very simple. The secret is to start in the middle of the fabric and in the middle of the chart, unless stated. Using this method, there will always be enough fabric to stretch and frame. It is always a good rule of thumb to cut your fabric at least 5 inches (12.5cm) larger than the intended completed dimension.

To find the middle of the fabric, fold it in four and press lightly. Open out and work a narrow line of tacking (basting) stitches following the threads to mark the fold and the centre (Fig 7). These stitches are removed when the work is completed.

Check you have all the colours you need and mount all the threads on a piece of card alongside its shade number. Sew a narrow hem or oversew the raw edges to prevent fraying. This can be removed on completion. Thread your needle with the required number of strands and you are ready to go!

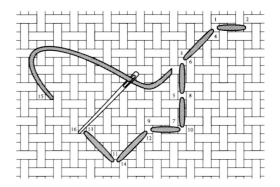

Fig 8 Back stitch

the black and white symbols refer to a back stitch outline and include a suggested DMC number. Outlining is very much an optional part of cross stitch. As you will see when you look through the book, outlining is not always necessary and is often a matter of taste.

TWEEDING

This is a simple way to increase the numbers of colours in your palette without buying more thread. To tweed, combine threads of more than one colour in the needle at the same time, and work as one. You can apply this method to French knots to great effect (Fig 9).

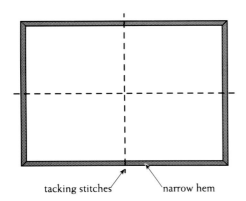

tacking stitches narrow hem

Fig 7 Fold fabric in four and tack along folds

BACK STITCH OUTLINING

Outlining is the addition of a back stitch outline to add detail or dimension to the picture (Fig 8). In the charts in this book the solid lines surrounding

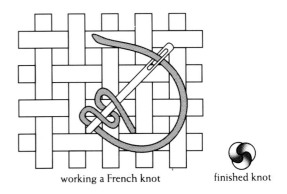

working a French knot finished knot

Fig 9 French knots

WASHING AND PRESSING CROSS STITCH

When a piece of cross stitch is complete, it may be necessary to wash the linen before finishing. Washing can give a piece of stitching a new life, but can also ruin your work if care is not taken.

Drinks, ice cream and cats cause havoc, so always keep your stitching covered and away from all of them.

If it becomes necessary to wash a piece of stitching, you will find that DMC or Anchor threads are usually colourfast, although some reds can bleed, so always check for colourfastness before immersing the project completely. To do this, dampen a white tissue and press the red stitches at the back of the work. Remove the tissue and look for any traces of red colour; if any are visible on the tissue, avoid washing the embroidery.

If the item is colourfast, wash it with bleach-free soap in hand-hot water, squeezing gently but never rubbing. Rinse in plenty of warm water and dry naturally. Do not use the tumble dryer.

To iron cross stitch, heat the iron to a hot setting and use the steam button if your iron has one. Cover the ironing board with a thick layer of towelling. Place the stitching on the towelling, right side down, with the back of the work facing you. Press the fabric quite firmly and you will see how much this improves the appearance of your stitching. Leave the embroidery to cool and dry completely before framing or making up the finished item.

STRETCHING AND MOUNTING

When mounting small cards or novelty projects, the whole procedure can be completed with double-sided tape, but it is worth taking more time and effort on larger projects.

You will need either acid-free mounting board or lightweight foam board, or you might possibly cover a piece of board with a natural fabric such as cotton, which can be fixed with a rubber-based adhesive and left to dry.

There are three methods of attaching the needlework to the board before framing: the first is to pin it to the edge of the board (Fig 10) and hold it in place with double-sided tape (Fig 12); the second option is to pin the embroidery to a fabric-covered board and stitch it in place (Fig 11), and the third is to pin it to the board and lace the excess fabric across the back with strong linen thread (Fig 13).

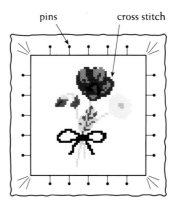

Fig 10 Placing pins around project to stitch

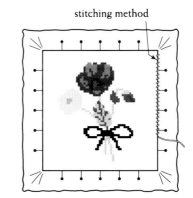

Fig 11 Stitching method

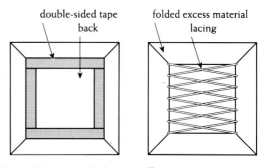

Fig 12 Taping method *Fig 13 Lacing method*

113

When you pin an embroidery to a board it must be centred and evenly stretched, because any wobbles will show when the design is framed. Measure the board across the bottom edge and mark the centre with a pin. Match this to the centre of the bottom edge of the embroidery and working outwards from the centre, pin through the fabric following a line of threads; repeat until all four sides are pinned.

MAKING CARDS

If you wish to make cards, you should first refer to the section on charts and calculate the size of your finished design before selecting a card with a suitable opening for your motifs. When the cross stitch is complete, press it on the wrong side and make up in the following way: unfold the card and position the cross stitch correctly, trimming away any excess fabric; open out the card and cover the back face of the opening with a thin coat of adhesive; press the fabric in place and fold over the third section of the card (Fig 14). Make sure that no adhesive oozes out and place the completed design on one side to dry. Double-sided adhesive tape may be used instead of glue if preferred.

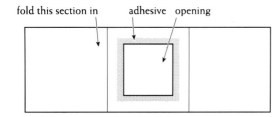

Fig 14 Making up a card

FRAMING

As you can see from some of the colour photographs in the earlier sections of this book, the way in which a design is framed can greatly affect its appearance. Framing by a professional can be very expensive, particularly if you want something a little different, but most of the framing and finishing techniques suggested in this book can be tackled by the amateur at home.

When choosing a frame for a particular project, select the largest moulding you can afford and do not worry if the colour is not suitable. Buy the frame, mount and glass in kit form (most framers do not mind selling the items separately) and then add the magic ingredient – car spray paint! Experiment until you find a colour or combination of colour which suits the stitching, and add polishes, liming wax, acrylic paints and matt varnish as preferred. To prevent the glass coming into contact with the stitching, a gold slip can be inserted.

As you will see from the picture on page 51, a mount (mat) can add dimension to very simple projects, and you can even spray paint the mount to co-ordinate with the frame!

CANVASWORK

CANVAS

Canvas is available in two main types: single thread (or mono) canvas and double thread (or Penelope) canvas. Single thread canvas is also available as interlock mono canvas and this is the type used for all the projects shown in this book. In this canvas, the threads along the length are in fact double threads, twisted together to hold the cross threads firmly in place. This produces a more stable canvas, which is ideal for working designs that include long stitches which might otherwise pull loose canvas threads together, making holes in your work. The disadvantage of interlock canvas is that it is only available in white. Take care not to stitch so tightly that the canvas shows through the work.

Canvas is most commonly available in four thread counts; the table below shows you how many strands of Appleton crewel wool and what size of needle you should use for each gauge. You can use any of the charts in this book with any gauge of canvas, just use the stitch counts given to calculate the dimensions of the finished design and choose the size most suited to the particular project that you have in mind (for further details see page 110).

CANVAS GAUGE	STRANDS OF CREWEL WOOL	SIZE OF NEEDLE
Threads per inch (2.5cm)	Working in tent stitch	
10	6	20
12	4	20
14	3	22
18	2	22 or 24

It is a good idea to bind the edge of your canvas with masking tape before you begin to stitch. This protects your hands and prevents the yarns from catching on the rough edge where the threads have been cut.

THREADS

Crewel wool is a fine, twisted two-ply yarn which may be used singly or as two or more strands in the needle. When several strands are used in this way, the wool lies flat and covers the threads of the canvas better. If you are a particularly tight stitcher you may choose to add an extra strand to the number specified, to achieve a good cover. This is also a good idea if you are working any design that involves a lot of long stitches, in which case you will often find that the canvas shows through more readily. We have chosen to use Appleton crewel wools throughout the book because the colour range is so large and each main colour is produced in a carefully graded range of shades. In one or two of the projects, you will notice that stranded cotton (floss) has been used on canvas. This adds a lustre to the motif and makes it stand out against the matt effect of the wool background. This technique works best on fine canvas, and you will find that all six strands of the stranded cotton (floss) cover 18-count canvas perfectly.

There is a very wide variety of yarns and threads on the market, and all stitchers seem to have their own particular favourites. If you have just discovered a new and tempting thread, do experiment with it, using the charts given in this book. We hope that the alternatives shown will encourage you to produce your own variations.

NEEDLES

Tapestry needles are blunt ended in order to pass through the canvas without catching. The size required will vary according to the number of strands that you are using and the gauge of canvas you have chosen. (See the chart in the previous canvas section for more details.) The needle, when threaded, should pass easily through the canvas. You should not have to tug it or you will wear the yarn where it passes through the eye of the needle. As you stitch, it is always a good idea to move the needle along the yarn to spread the wear and tear. As you stitch, you will find that your yarn will become twisted; drop the needle every now and again and let it hang freely to allow the yarn to untwist. As for cross stitch, treat yourself to a gold-plated needle for canvaswork – it will never tarnish.

EMBROIDERY FRAMES

At the risk of being shot down in flames by the more traditional needlewomen amongst us, we have to say that the use of a frame for canvaswork is a matter of personal preference! We recommend the use of a frame for any design which involves long stitches or which requires careful counting from a chart. A lot of the projects shown in the previous chapters had the design or motif worked on a frame and then the background filled in with the canvas in the hand. If you do work in the hand, you should roll the canvas rather than crunch it up and you will need to stretch the finished piece carefully as the canvas becomes more distorted when held in the hand.

Many types of frames are available; choose the one with which you are most comfortable and that fits your budget. Follow the manufacturer's instructions for mounting the canvas.

Never use an embroidery hoop on canvas unless you have one that is big enough to contain the entire worked area. Where the canvas has been stretched tightly between the rings, it will become distorted, and if this distortion is then stitched over, a shadow may remain in the embroidery, even after stretching.

THE CHARTS

See the previous cross stitch section; the information on charts is the same for canvaswork, but do not forget that you will need to choose a suitable background colour to cover your canvas and decide on the extent of the background area according to your chosen project.

WHERE TO START

When cutting the canvas you should allow at least 6 inches (15cm) extra to the completed

dimension on both the length and breadth; this will leave at least a 3 inch (7.5cm) unstitched margin for stretching and mounting. As for counted cross stitch, start in the middle of the canvas and the middle of the chart, and your design will always be centred. Stitch the design first and, once this is completed, it is often helpful to draw a pencil line on the canvas to mark the extent of the background before you begin to fill in the background stitches.

CANVASWORK STITCHES

For some of the projects in this book you will need to refer to this page and the crewelwork stitches (pages 119–21). This is because some of the stitching is a combination of canvas and simple crewelwork, for example the woolwork cushions in Chapter Three.

TENT STITCH

There are two methods of working tent stitch (Fig 15). Diagonal, as shown in the bottom diagram, and tent as shown above. Use diagonal where possible as it will distort your canvas less. Note that the thread is started with a knot on the surface; the knot is then trimmed off when enough stitches have been made to cover the thread end. Finish off by running the thread under the last few stitches.

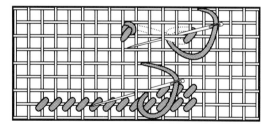

Fig 15 Two methods of working tent stitches

CROSS STITCH

The method for working cross stitch on canvas is slightly different to that used on evenweaves (Fig 16). You will find that if you follow this method you can work quite quickly and easily, without necessarily using a frame. If you are right-handed, work from right to left, if you are left-handed, work from left to right. When you reach the end of a row or colour, turn your work to go back the other way.

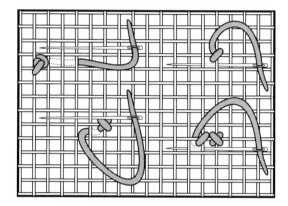
Fig 16 Cross stitch

GOBELIN

This is a very useful filling stitch which can be substituted for the smaller, diagonal tent stitch if you want to cover a large background area more quickly. It must always be worked over an even number of threads but the number can vary according to the effect that you require on a particular project, and it may be worked either horizontally or vertically (Fig 17).

Fig 17 Gobelin stitch

LONG-LEGGED CROSS STITCH

Move four threads forwards and two threads back as you work this stitch, which gives a plaited braid effect that is very useful for finishing off around a tent stitch square (Fig 18).

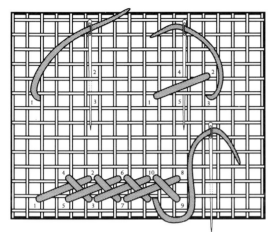

Fig 18 Long-legged cross stitch

BACK STITCH OUTLINE

Worked with tent stitch to enhance details. Always work the design and any surrounding background before the outlining, as it will not show unless it sits on top of the tent stitch (Fig 19). Use only one, or possibly two, strands of crewel wool, depending on the size of the tent stitch.

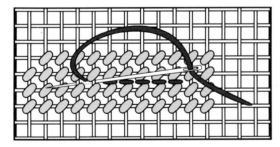

Fig 19 Back stitch outline

STRETCHING AND STARCHING CANVASWORK

It is in the nature of canvaswork to distort as it is worked, particularly when using tent stitch. Even if you have worked on a frame and you think your embroidery is square you should still stretch and starch. You will be surprised how

much the appearance is improved. Not only will the piece be perfectly square, but the tension of the stitching will become more even. If you are tempted to miss out this vital stage between the stitching and the making up of your project, it will never look as good as it might.

You will need:
A large, flat clean board (chipboard is ideal)
A sheet of dressmaker's graph paper (marked in
3/8 inch/1cm squares)
Plenty of 1 inch (2.5cm) nails
A hammer
Cold-water starch (this is most easily available as wallpaper paste; make sure that you buy a brand without plasticizer – we used a brand called Lap, which is widely available)
Masking tape
A kitchen palette knife

Cover the board with the sheet of squared paper and secure this with masking tape around the edge Place the embroidery, right side down, on top of the squared paper. You will be able to see the squares of the paper through the unstitched margin of the canvas. Begin nailing in one corner, about 2 inches (5cm) away from the embroidery. Hammer the nails in just far enough to hold firmly into the board. Follow one line of holes in the canvas and nail into every second intersection of a line in the paper. It is important to keep the nails no more than 3/4 inch (2cm) apart, or the edge of the embroidery will not be straight. When you have completed the first side, go back to the corner and repeat for the side at right angles to it. Now draw pencil lines from the last outer nail on each of these sides, following the grooves in the canvas, to cross at the corner diagonally opposite the one that you started with. Lift the canvas and using the squares find the position on the paper where the lines cross from the nailed corners; this is where the last corner of the canvas must be stretched to. If your work is badly distorted it will help to dampen the embroidery at this stage. Pull out the embroidery; nail this last corner, and then finish nailing the last two sides.

Mix a small quantity of paste to the consistency of soft butter and, using the palette knife, spread it evenly but sparingly over the back of the embroidery. Try not to let the starch go over the edges of the embroidery as it will stick the work to the paper and spoil the board for future use. Allow to dry naturally and completely. Finally remove the nails and turn the embroidery over to reveal a beautifully square and even piece of work.

CREWELWORK

FABRICS

The crewelwork designs in this book, except for silk miniatures in Chapter 5, are all worked on pure linen twill. This is the very best of fabrics for crewelwork but, unfortunately, is often difficult to find. Maybe if we all keep asking in needlework shops for linen twill we can create a demand and the linen mills will oblige! There are many other suitable fabrics on the market, and the choice is much wider than for counted embroidery, as the fabric need not be of an even-weave. Your chosen fabric should have a close weave, so that the threads will not separate when you stitch, and it should be of medium weight. The colour is up to you, but look at it with the thread colours before you buy. Ask your local embroidery shop for a fabric suitable for surface embroidery if you are in doubt. Some of the finer counts of evenweave linen are also suitable for crewelwork (see the Lily on page 93). Do not be afraid to experiment if you like the look and colour of a fabric; however, we advise you to stick to natural fibres rather than synthetics.

The pure silk dupion used for the silk miniatures is a dress fabric often used for weddings; if your embroidery shop is unable to supply you, try your nearest dress fabric stockist.

To prevent fraying, you can work a narrow hem around the edge of your fabric or bind the edge with masking tape before you begin to stitch. When cutting your fabric you should allow at least 6 inches (15cm) extra to the completed dimension on both the length and breadth, which will leave at least a 3 inch (7.5cm) border for stretching and mounting. For a large design, you should allow more, and if you are in any doubt as to how you intend to mount your work, allow plenty of space around the design while you decide as you work.

THREADS

The dictionary defines crewel as 'a loosely twisted worsted yarn used in embroidery' and so traditionally crewelwork has always been worked with crewel wool yarn. There are several types on the market; we have chosen Appletons crewel wool for its availability and superb colour range. If you particularly want to use another type, use the colourings of the line drawings to help you choose a suitable set of shades in your chosen brand.

We have also included, in Chapter 5, free surface embroidery in stranded cotton (floss) on silk. This is not strictly crewel embroidery, but the stitches and techniques are exactly the same as those used in crewelwork. In this chapter, Anchor alternatives to DMC are quoted, but again an exact colour match is not possible.

NEEDLES

Crewel needles have sharp points and long eyes for easy threading. They come in a wide range of sizes, the most useful of these being 7 and 5 (7 being finer than 5). The finer the needle, the better it is for crewel embroidery, but be guided by how easily you can thread your needle and choose the size accordingly. Gold-plated crewel needles are now also available; the extra smoothness of gold is a great advantage when working this type of embroidery.

EMBROIDERY FRAMES AND HOOPS

You should always use a frame or hoop when doing crewel embroidery. The length of some of

the stitches involved means that it is very easy to pull up the fabric unless it is held taut in a frame or hoop. If you decide to use a rectangular frame (the type used for a larger design) you will find a wide choice of sizes and types. The fabric is stitched to webbing along the width of the frame and the excess taken up by rollers at the top and bottom. If you use a hoop, ensure that the entire design is well within the stitching area of the hoop. You should not try to fit a hoop over worked areas, as it may damage your stitches and will not work well over the thickness of the embroidery. (For diagrams of frames and hoops and advice on their use see the information included in the cross stitch Materials and Equipment section on page 110.)

THE COLOURED LINE DRAWINGS

The method for tracing the line drawings on your fabric is given in detail on page 12. Transfers are available for all the line drawings in this book if you prefer not to use the tracing method. These are modern transfers and will provide at least two imprints from each design (for details of suppliers see page 127). The colouring of the drawings is only intended as a guide; crewelwork is a free form of embroidery and you will have to make some decisions for yourself. Please do not be frightened by the absence of any lines to follow; once you start to stitch you will be surprised at how easy it is, and how creative you can be!

CREWELWORK STITCHES

For some of the projects in this book you will need to refer to this page and the canvaswork stitches (pages 114–17). This is because some of the stitching is a combination of canvas and simple crewelwork, for example the Tea Cosy in Chapter 2.

SPLIT BACK STITCH

This is similar to simple back stitch described previously on pages 112 and 117, except that the needle is inserted into the previous stitch, taking care to split the thread (Fig 20).

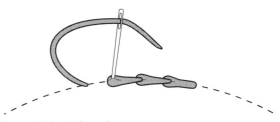

Fig 20 Split back stitch

LONG-AND-SHORT STITCH

In fact, only the first row worked consists of long and short stitches; the following rows are all long. Begin at the outside edge and then stitch following rows into the stitches already worked, splitting the threads to blend the stitches and colours (Fig 21). Do not be afraid to make stitches longer than you feel you should be as they will be shortened by the next layer of stitching. Do not try to follow this diagram too rigidly; you will have to adapt to the shape that you have to fill.

119

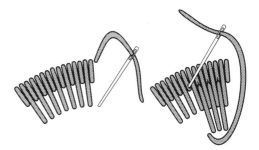

Fig 21 Long-and-short stitch

STEM STITCH

Hold the thread down each time you make a stitch to keep it out of the way and also to maintain an even tension (Fig 22).

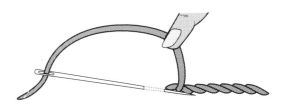

Fig 22 Stem stitch

SATIN STITCH

Flat stitches are laid side by side; always come up the same side and down on the other, so that you cover the back of the fabric as well. In this way, your stitches will lie closely and neatly beside each other (Fig 23).

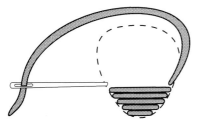

Fig 23 Satin stitch

BUTTONHOLE STITCH

This is shown here with long and short stitches (Fig 24), to lead into long-and-short stitch. Hold the thread down as you make each stitch.

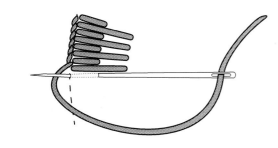

Fig 24 Buttonhole stitch

FRENCH KNOTS

Bring your needle up through the fabric; hold the thread taut and wind the needle once around the thread; pull the twist down onto the surface of the fabric, and insert the needle into almost the same place as it came out (but not exactly the same place or your knot will disappear through the hole) (Fig 25).

Pull the needle carefully through the fabric, still keeping tension on the thread until you have to let go. If you take the thread more than once around the needle you will tend to get a loose-looking knot; if you want a larger knot, use more strands of your thread.

Fig 25 French knots

BULLION KNOTS

The length of the finished coil is determined by the length of the first stitch. Wind the thread around the needle until the length of the coil equals the length of the first stitch. Hold the thread coil and needle between your thumb and finger and gently but firmly pull the needle through. Allow the coil to turn back on itself and push the needle through to the back of the fabric (Fig 26).

Fig 26 Bullion stitch

CHAIN STITCH

Hold the thread down with your left hand as you stitch. Work evenly-spaced stitches along a line. Do not pull your stitches too tight (Fig 27).

Fig 27 Chain stitch

LAZY DAISY (DETACHED CHAIN)

Form a loop by bringing the thread up through the fabric and then down the same hole again. Bring the thread up again the required length away from the first stitch and then gently pull the loop to fit loosely. Make a small stitch to secure the loop (Fig 28).

Fig 28 Lazy daisy (detached chain) stitch

WASHING CREWELWORK

It is advisable to wash crewelwork once you have completed the stitching. If you have used the tracing method described in the text, you will need to rinse away the water-soluble pen lines, and washing with a gentle, bleach-free soap will freshen the piece, which will have been well handled as you stitched and may have become dirty. Rinse well in hand-hot water and lay on a towel. Roll the towel with the embroidery in it to remove excess moisture and then allow the finished piece to dry naturally.

PRESSING CREWELWORK

If your piece is fairly small, ironing should be sufficient to remove creases and puckers caused by the stitching. If your work is very puckered or quite large you may need to stretch it (see next section).

To iron crewelwork, use a hot setting. If you do not have a steam button on your iron, you will need a damp cloth. Cover the ironing board with two layers of towelling and place the embroidery on the towelling, face down with the back of the work towards you. Press firmly, using plenty of steam or the damp cloth. Never press crewelwork on the right side. Leave the embroidery to cool and dry before framing or making up.

STRETCHING CREWELWORK

If you have completed a large piece of crewelwork or have ironed it as above, but are not satisfied, you will need to stretch your embroidery. The method is similar to that used for canvaswork, but instead of covering the back of the pinned (dry) embroidery with paste, pin it face up and dampen the surface with water from a spray (available in most garden shops for spraying house plants), filled with tap water. Do not worry if the fabric seems to stretch and go loose on the nails; it will tighten again as it dries, and this will remove the creases. Allow to dry naturally, and remove the nails.

MOUNTING CREWELWORK FOR FRAMING

The method for mounting crewelwork is exactly the same as for cross stitch as described in pages 108–13. You may notice that the framed crewelwork projects in this book have been padded before framing. This is very easily done by cutting a piece of polyester wadding to exactly the same size as your mounting board and then attaching this wadding to the board with double-sided tape. Pin your embroidery over the padded board in exactly the same way as described for cross stitch. Only pad your embroidery in this way if you are mounting without glass, or you will simply push the surface of the embroidery against the underside of the glass.

MAKING THE PROJECTS

TWISTED OR MONK'S CORD

This is a simple but effective cord. We used it to make the ties on the needlework pictured on page 19 and for the cords on the key fob and the scissor keeper on page 53. Decide how long and how thick you want the cord to be. You will require enough strands to make half the desired thickness. They should be three times the desired length. Tie a knot at both ends. Secure one end to a door knob (or persuade a friend to hold it). Twist the other end until the yarn begins to double back on itself when you slacken the tension slightly. Fold it in half, letting go of the centre point carefully and holding the two ends together. The cord will twist and you should tie the loose ends together without letting them go. If you need to cut the cord, make sure the end is knotted or the cord will unravel. If you require a thicker cord, start with a longer length and twist and fold twice.

SIMPLE VELVET-BACKED PINCUSHIONS

Pictured on page 9.

Square of velvet, the same size as your embroidery
(plus ½ inch/12mm seam allowances)
Polyester filling

This is the simplest and quickest way to make a pincushion. We have used velvet because the pile of the fabric disguises the seam well. Place the velvet and the embroidery right sides together and machine-stitch or hand-stitch into the edge of the embroidery around three sides and all four corners, leaving a gap in one side to allow you to add the stuffing. Turn right side out, fill firmly with stuffing and hand-stitch the opening. For a special gift, you could add a twisted cord around the edge of the pincushion or small tassels on each corner.

NEEDLEBOOK

Pictured on page 19

Yarn used for the background of the embroidery
Felt the same size as the embroidered area
Small piece of flannel or felt to make the 'pages' for
the needlebook

Trim the unworked canvas to within ½ inch (12mm) of the embroidery, and then fold in the raw edges and catch-stitch them to the back of the embroidery. Make two 6 inch (15cm) lengths of twisted cord (for instructions of making the cord see above). Attach one of these cords to each side of the book. Cut the felt to fit the embroidery and pin together. Slipstitch around the edge. Cut two pieces of flannel or felt measuring 1½ inches (4cm) less than the embroidery in each dimension to make the 'pages' of the needlebook (use pinking shears if you have them). Fold these pages in half and backstitch them neatly to the spine of the book.

EGG COSIES

Pictured on page 55.

For both cosies you will need:
A piece of felt 10 x 10 inches (25 x 25cm)
1 yard (90cm) of satin bias binding

Trim the excess canvas around each egg cosy piece to within ¾ inch (2cm) of the embroidery. Cut four identical shapes in felt. For each cosy, take a felt shape and place it behind an embroidery; pin them together. Trim the bottom edge close to the embroidery and bind with satin binding. Take the remaining felt shape and bind the bottom edges. Pin the front of the egg cosy to the back and sew around the embroidery edge. Trim this outer edge well and bind with satin binding, tucking the ends in carefully at each side.

A Plain Piped Cushion

Pictured on pages 23 and 35

20 inches (50cm) of furnishing fabric
2 yards (180cm) of No 3 piping cord
A cushion pad 1–2 inches (2.5–5cm) larger than the
finished cushion
Button thread for hand sewing

Cut a square of furnishing fabric 2 inches (5cm) larger than the finished area of embroidery. To make the piping, cut enough bias strips 2 inches (5cm) wide to go round the cushion. It is important that these strips are on the true bias of the fabric and are cut at a 45 degree angle.

Stitch together enough bias strips to make the required length. Fold the strip in half and, using the piping foot of your sewing machine, stitch the cord into the folded bias.

For the canvaswork cushion cover, trim the unstitched canvas edge to within ¾ inch (2cm) of the embroidery, clipping away each corner. Turn the edge under and catch down the unstitched canvas to the wrong side of the embroidery, using a herringbone stitch. Now you are ready to attach the prepared piping: find the centre point of the edge that will be the bottom of the cushion and mark it with a pin. Leave an end of piping hanging loose to make a join at this point later. Stitch the piping to the embroidery, using slipstitch and button thread. Make these stitches into the tube of the piping to keep it tight against the edge of the embroidery. If you pull the thread tightly, you will find that the stitches disappear into the edge of the embroidery. Clip into the seam allowance at each corner. To make a neat join in the piping when you reach the bottom edge again, lay one end over the other and cut away the excess on each end, leaving a ½ inch (12mm) seam allowance. Machine or hand-stitch a straight seam. Trim the two ends of the cord so that they butt up to each other and then insert them back into the piping. Finish attaching the embroidery to the piping across the join; turn over and lay the backing square over the back of the embroidery. Turn in the edges to fit and pin, trimming the

corners as necessary and leaving an opening in one side to insert the cushion pad. Slipstitch the back to the piping in the same way as you did for the front. Insert the cushion pad and sew up the opening. Give the finished cushion a good beating to force the cushion pad into the corners.

The crewelwork cushion cover is made in much the same way as the above, but use the piping (or zipper) foot of your sewing machine to attach the piping around the embroidered front cover. Join the piping ends together as already described, then stitch the back and front cover together, again using the piping foot and stitching closely against the edge of the piping. Finish as for the canvaswork cover.

An Inset Cushion With Mitred Corners (Piped or Frilled)

Pictured on pages 31 and 75

For a piped edge you will need:
20 inches (50cm) of furnishing fabric
2 yards (180cm) of No 3 piping cord
A cushion pad 1–2 inches (2.5–5cm) larger than the
finished cushion

For the frilled edge you will need:
28 inches (70cm) of fabric fine enough to be gathered
easily
A cushion pad as above

The seam allowance throughout is ½ inch (12mm). Measure the embroidery and decide on the size that you would like the finished cushion to be. Subtract the embroidery measurement from the finished measurement, divide this by two and add on two seam allowances; this gives you the width for the border pieces. Cut all four border pieces.

Trim the unstitched canvas edge to within ¾ inch (2cm) of the embroidery. Find the midpoint of each edge by folding, and mark it with a pin. Fold each border panel in half to find the centre point and mark with a pin. Pin the border

panels to the embroidery, matching the centre points, and leaving the ends free. Machine stitch these seams using a piping foot. To avoid any unwanted white canvas showing on the finished cushion, take great care to stitch very close to the edge of the embroidery; the stitching of each side of the cushion should meet at the corners through the same canvas hole of the embroidery. If you now fold the embroidery in half diagonally, wrong sides together, you will find it easy to mitre the corners by stitching a line from the corner of the embroidery to the corner of the border panels. Trim the excess cloth on these seams and clip the corners. Repeat this process, folding on the other diagonal, to mitre the other two corners.

PIPED CUSHION

Make the piping as for the plain piped cushion and, using a piping foot, machine the piping to the outer edge of the front, clipping the piping seam allowance at the corners as you go. Make a join in the piping at the bottom as for the plain piped cushion (for detailed instructions see page 123). Lay the back over the front, right sides together, and stitch, working tightly against the piping and leaving an opening at the bottom to insert the cushion pad. Turn right sides out, insert the pad and slipstitch the opening to finish the cushion.

FRILLED (FLOUNCED) CUSHION

Cut sufficient pieces of fabric for the frill (flounce) to run twice around the edge of the cover, cutting each twice the width of the finished frill (flounce) plus two seam allowances. Seam the pieces together to form a continuous loop and fold this in half, right sides out. Run gathers along the raw edges and pull them up to fit the outer edge of the cushion. Pin the frill to the front, spreading the gathers evenly, with the folded edges facing the centre of the cushion. Stitch this seam. Pin the back of the cushion to the front, right sides together. Stitch, leaving an opening to insert the cushion pad. Turn right sides out, insert the cushion pad and slipstitch the opening.

SEWING TIDY

Pictured on page 44

½ yard (45cm) of medium-weight fabric for backing and lining
Polyester filling

The sewing tidy is really only a pincushion with a pocket hanging off each side. Trim the excess canvas around each of your five flower squares to within ¾ inch (2cm) of the embroidery. Cut five squares of fabric the same size as the flower squares. Taking the four flowers that you have chosen and are to become the pockets, place them right sides together with a fabric square and stitch around the bottom and the two sides. Turn right sides out. Cut four oblongs measuring 11½ x 6½ inches (29 x 16.5cm); fold these in half and stitch up the sides, tuck one into each pocket to form a lining. Fold in the edges of the lining and canvaswork and slipstitch them together, leaving the backing and the corresponding lining edges free. You will now have four pockets with a seam allowance on the back edge. Attach one pocket to each side of the pincushion square and pin the remaining fabric square to the back of the pincushion, enclosing the seams of the pockets. Slipstitch around the pincushion backing, filling it up with stuffing just before you close the last side.

TEA COSY

Pictured on pages 55 and 57

For this you will need a piece of felt large enough to cut two shapes the same size as the embroidered pieces (felt is usually sold in cut pieces, and you may need to take your finished embroideries with you to check sizes). Trim the excess canvas around each house piece to within ¾ inch (2cm) of the embroidery. Cut two identical shapes in felt (omitting the chimney). Carefully sew the top roof seam together, stitching into the last row of holes used for the canvaswork to ensure that no white canvas shows. Match the peak of each side roof to the end of the roof top seam and

pin in the side panels, then stitch these seams. Make the lining in the same way and tuck it into the tea cosy. (You might like to add a layer of polyester wadding/batting for extra insulation at this point.) Trim the bottom of the lining to fit, and slipstitch it to the bottom of the embroidery, turning up the unworked canvas around the lower edge of the cosy.

A Nightdress Case

Pictured on page 99 and below

Trim the embroidery to measure 13 inches (33cm) across and 11 inches (27.5cm) down. Taking a ½ inch (12mm) seam allowance, join top of the embroidery to the shorter piece of satin fabric. Pin the layers of backing fabric, wadding/batting and embroidered section together, with right sides outside. Make sure all the layers they are smooth, and tack (baste) them together around the edge, again taking a

½ inch (12mm) seam allowance. Neatly trim all the layers back to a ¼ inch (6mm) allowance.

Take a plate or saucer, and use dressmaker's chalk or a light-coloured pencil to mark the rounded corners at the bottom of the embroidery. Tack (baste) along the rounded lines to meet the existing lines, then trim away the excess, still leaving a ¼ inch (6mm) allowance.

Topstitch a length of binding across the short edge furthest away from the embroidery (leave the edges at each end raw). Gather the lace to fit around the embroidery and baste it in place (following the existing basting line) so that it lies on the embroidery, the raw edges all parallel. Bring up the lower, bound edge to make a fold 10 inches (25cm) deep and stitch along the side edges to hold the fold, stitching along the tacked (basted) lines. Topstitch bias binding from one corner of the lower, folded edge of the bag, up one side, around the curved flap, and back down the other side, turning in the ends of the binding neatly.

125

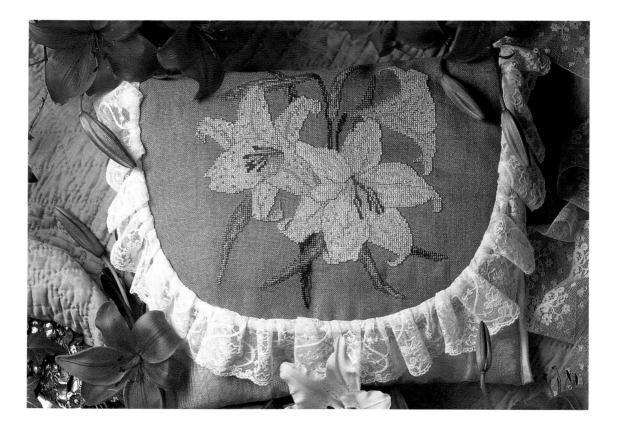

Suppliers

THREADS, FABRICS AND CANVAS

DMC Creative World Ltd, Pullman Road, Wigston, Leicestershire LE18 2DY Tel: 01533 811040

DMC Corporation, Port Kearny, Building 10, South Kearny, New Jersey, USA Tel: 201-589-0606

DMC Needlecraft Pty Ltd, PO 317 Earlswood, NSW, Australia Tel: 612 5593 088

APPLETON YARN

UK Appleton Bros., Thames Works, Church Street, Chiswick, London W4 2PE

USA Potpourri Etc., PO Box 78, Redondo Beach, Ca. 90277., USA

Australia Clifton H. Joseph & Son (Australia) Pty. Ltd, 391-393 Little Lonsdale St., Melbourne, Victoria 3000.

LINENS AND AFGHANS

Fabric Flair Ltd, The Old Brewery, The Close, Warminster, Wiltshire BA12 9AL Tel: 0800 716851

Campden Needlecraft Centre, Chipping Camden, Glos. GL55 6AG Tel: 01386 840583

Wichelt Imports, Rural Route 1, Stoddard, WI 54658, USA Tel: 608-788-4600

Stadia Handcrafts, PO Box 495, 85, Elizabeth Street, Paddington, NSW 2010, Australia Tel: 02328 7973

LIBERTY FABRICS

Liberty plc, 210-220 Regent Street, London W1R 6 AH Tel: 0171 734 1234

Liberty of London Inc. 108, West 39th St., New York, NY 10018, USA Tel: 212-459-0080

Norman Vivian Pty Ltd, 18, Belmore Street, Surry Hills, NSW 2010, Australia Tel: 2212 1633

FRAMES AND CARDS

Three-fold cards and the small silk miniature frames: The Sewing Basket, 4 Edinburgh Road, Formby, Liverpool L37 6EP Tel: 01704 873301

Shaker box and pretty wall cupboard: Sudbury House, Old Lyme, CT 06371, USA. Available in the UK through Framecraft Miniatures Ltd, 148-150 High Street, Aston, Birmingham B6 4US Tel: 0121 359 4442

JANE GREENOFF AND THE INGLESTONE COLLECTION

Jane discovered counted cross stitch through a neighbour, and within six months had marketed her first design, having perceived a gap in the market for a genuinely English product. Thus the Inglestone Collection began: it was the first company in the UK to gold plate tapestry and cross stitch needles, and has the only British working paper-perforator, made for the manufacture of Stitching Paper.

The Inglestone Collection produces Jane Greenoff's counted cross stitch kits and charts, including some of the designs in this and previous books. Ask at your local needlework shop for details or write (enclosing a stamped addressed envelope) to Jane Greenoff's Inglestone Collection, Yells Yard, Cirencester Road, Fairford, Glos. GL7 4BS or telephone 01285 712778.

In the USA, Jane Greenoff's books and kits are available from Designing Women Unlimited, 601 East Eighth St., El Dorado, Arkansas 71730 USA Tel: 501-862-0021

SUE HAWKINS AND NEEDLEWORKS

Sue's interest in embroidery and treasured textiles began while she was working with an antique dealer who specialised in 17th-century embroidery. It is from these early pieces that her own designs later evolved. In 1991 she sold her needlework shop in Cheltenham to concentrate on designing for her own company, Needleworks, and on teaching small workshops at home. Needleworks produces counted canvaswork and crewelwork kits together with a unique range of transfer packs of her designs. These are available through good needlework shops. Transfers of all the line drawings in this book are available by writing for details (enclosing a stamped addressed envelope) to Needleworks, The Old Schoolhouse, Hall Road, Leckhampton, Cheltenham, Gloucestershire, GL53 0HP or by telephoning 01242 584424.

Needleworks kits, transfer packs and Sue's first book are available in the USA from Designing Women Unlimited (see page 126).

ACKNOWLEDGEMENTS

Our grateful thanks go to:
Bill and the Greenoff children for remaining sane and John and the Hawkins girls for remaining at home!
All at the Inglestone Collection, who kept the business thriving in J.G.'s absence.
Viv Wells and Brenda Morrison for all the help with the planning of this beautiful book.
Ian Lawson-Smith and all at Ilsoft for J.G.'s wonderful cross stitch programme and all the support, often above and beyond the call of duty!
Ethan Danielson for making sense of the cross stitch charts.
Especially to all the stitchers: Eileen Blackeby, Caroline Gibbons, Dorothy Presley, Hanne Castelo, Sarah Haines, Jenny Kirby, Su Maddocks, Sophie Bartlett, Carol Lebez, Sarah Day, Christine Banfield, Margaret Cornish, Kathy Elliot, Jill Vaughan, Barbara Webster, Sharon Griffiths and Vera Greenoff.
Tunley & Son Ltd, Swindon, for their frames.

THREADS AND FABRICS

Appleton Brothers for their wonderful colours.
Cara Ackerman at DMC Creative World for fabric, threads and canvas.
Len and Malcolm Turner of Fabric Flair Ltd.
Vaupel and Heilenbeck for generous supplies of linen band.

127

Index

Numbers in *italics* indicate illustrations